IMAGES
of Rail

RAILROAD DEPOTS
OF MICHIGAN
1910–1920

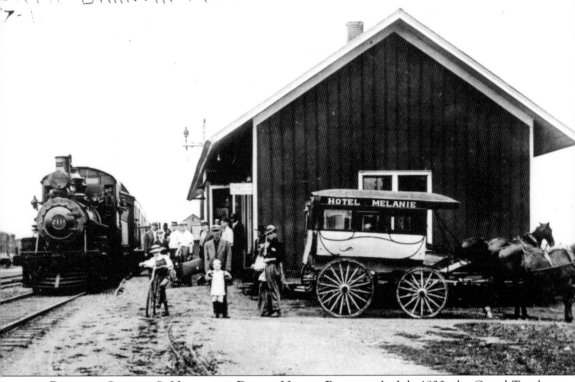

Pontiac, Oxford & Northern Depot, North Branch. In July 1920, the Grand Trunk Railway had been in control of the Pontiac, Oxford & Northern Railroad for nearly a decade and rooms were $2 a night at the Hotel Melanie in North Branch. The hotel's horse-drawn coach is shown meeting the northbound passenger train, which originated in Pontiac. Once passengers and their luggage have been accommodated, the train will continue its 2-hour-and-17-minute journey to Caseville. (James Harlow collection.)

On the cover: **Michigan Central Depot, Mason.** Mason was located 25 miles north of Jackson on the Michigan Central Railroad's Saginaw Branch and was named after the state's first governor, 23-year-old Stevens T. Mason. The railroad built an attractive depot here, which featured contrasting shades of brick and a tall hip roof. A southbound train makes its way past the Mason depot and sidings filled with freight cars, as the crossing watchman and several others look on. (Dave Tinder collection.)

IMAGES
of Rail

RAILROAD DEPOTS OF MICHIGAN
1910–1920

David J. Mrozek

ARCADIA
PUBLISHING

Copyright © 2008 by David J. Mrozek
ISBN 978-0-7385-5192-0

Published by Arcadia Publishing
Charleston SC, Chicago IL, Portsmouth NH, San Francisco CA

Printed in the United States of America

Library of Congress Catalog Card Number: 2007939957

For all general information contact Arcadia Publishing at:
Telephone 843-853-2070
Fax 843-853-0044
E-mail sales@arcadiapublishing.com
For customer service and orders:
Toll-Free 1-888-313-2665

Visit us on the Internet at www.arcadiapublishing.com

For my two special girls,
Lynne and Brittany

CONTENTS

ACKNOWLEDGMENTS

The postcard collections of James Harlow and Dave Tinder made this book possible. Without their generosity, assembling a book like this would have been much more difficult, if not impossible.

James Harlow has an extensive knowledge of Michigan railroad history and a passion for railroad stations in particular. Far more than just a railroad historian, Jim also has an intimate knowledge of railroad operations as well. For years, as a Conrail operator, he saw to it that trains ran safely and efficiently at several interlocking towers in metropolitan Detroit.

Dave Tinder has amassed an amazing collection of Michigan postcard scenes, which goes well beyond railroad station subjects. In August 2006, the Michigan Historical Museum, in partnership with Dave and the University of Michigan's Clements Library, created a special postcard exhibit entitled Michigan's Family Album, which featured images from every county in the state. Dave is now in the process of transferring his collection to the Clements Library at the University of Michigan in Ann Arbor, so that future generations can enjoy the fruits of his outstanding Michigan preservation effort.

Thank you gentlemen for sharing your postcards and also for sharing your knowledge of "things Michigan."

Another word of gratitude goes out to Pam Chipman, who created the six maps for the book. Her computer skills and ability to manipulate PDF files far exceed mine. Michael Kreiser, my good friend from Dresden, Germany, and John Pearson at Arcadia Publishing also had a hand in tweaking the maps for publication. Many thanks to them as well.

And then there is my mom, Tracy Mrozek, who allowed my interest in railroads to run its natural course as a teenager in Dearborn. Along the way, she also encouraged my love of reading and always insisted on good writing. Her mastery and command of the English language has always been something that I have admired. Anna Wilson at Arcadia Publishing should also be recognized for the text enhancing modifications she made. Thanks, Mom. Thanks, Anna.

My wife Lynne and my daughter Brittany also deserve a special note of thanks for the encouragement they provided along the way, and for keeping things running on the home front, while I sorted through old postcards, searched for information, wrote, and rewrote the manuscript. Thanks, girls.

Over the course of this journey, I have been blessed with an outstanding cast of support people, so this book is as much theirs as it is mine. However, I must assume the ultimate responsibility for any errors that may have crept into the finished product.

Readers, I hope you find the book worthwhile and enjoyable.

INTRODUCTION

It was a different era. There were no jet aircraft, no interstate freeways, and automobile ownership was limited. It was an era when the railroads were king. They were the primary means of transport as the second decade of the 20th century began. If you needed to travel from Petoskey to East Jordan, Michigan, the most convenient way would be to board Pere Marquette Railroad train No. 6 in Petoskey at 8:35 a.m. and ride to Bellaire, arriving there at 9:59 a.m. You would then make an across-the-platform transfer at Bellaire to East Jordan & Southern Railroad train No. 2 at 10:10 a.m., and arrive in East Jordan at 11:10 a.m. The 61-mile trip by rail would have consumed 2 hours and 35 minutes and cost $1.03 in October 1909.

The Michigan railroad network reached its peak in 1914, with 9,711 miles of track in service, including electric interurban railway routes. On the main lines, passengers usually had their choice of several departure times during the day, while most branch lines offered once-daily connecting service to the primary lines. In 1920, passenger train service in Michigan was extensive, although the network had begun to shrink a bit, with a net loss of 123 miles of track over six years. John R. Wood was still publishing the monthly *Michigan Railway Guide*, which sold for 20¢ and detailed the transportation offerings of the steam railroads, electric interurbans, intercity bus lines, and steamboat companies. In addition to the schedules presented, the guide also contained advertisements for a variety of "modern, absolutely fireproof, homey, and clean hotels, with hot and cold running water," for those travelers requiring overnight accommodations.

Even before the dawn of the 20th century, railroad stations were a source of company and community pride. In cases where a town was served by more than one railroad, companies often tried to "one-up" the competition across town by building a more elaborate station building. Communities likewise lobbied railroad officials for more attractive stations, since the depot was considered the gateway to their cities. The railroad station was frequently the first building an out-of-town guest would see, and would influence that all-important first impression of the community he or she was entering.

What would it be like to step back in time 90 years and experience rail travel and Michigan's railroad stations of yesteryear? Fortunately for present-day railroad station enthusiasts, seeing what railroad stations were like in their heyday is possible through the medium of preserved postcards. Around 1910, Michigan and the nation were involved in a postcard craze. Sending and collecting postcards had become a national pastime. Telling family and friends back home that they had arrived safely in Charlevoix this afternoon on Pere Marquette train No. 1, that the weather was fine, and that they were having a great time on their vacation had become a tradition. And the price was certainly right—two postcards for a nickel and a penny to mail them anywhere in the country. Natural wonders, street scenes, trains, and oceangoing ships were typical postcard subjects. However, given the fact that railroads played such a significant role in American life, train stations were desirable subjects for postcard photographers. Their work provides a unique window into the past, to a time to when the railroads were king, and railroad stations were an important part of community life. This volume is a sampling of Michigan railroad stations as they existed during the postcard era.

Postcard-era photographers produced railroad station images of varying quality. Collectively their work ranged from outstanding to dismal. In some cases, it appears that many amateur photographers traveled around the state and took depot photographs without any regard to good lighting, interesting composition, or even taking care to set up their tripods on level ground. While the images they created show rare glimpses of stations that no longer exist, their quality is so poor that reproducing them is nearly impossible. On the other hand, many outstanding views of Michigan depots were made during this period. For example, Vincent and Sons Publishing produced an outstanding postcard of the Grand Trunk Railway depot at Lapeer. The photographer stood west of the station taking in the entire scene—the station, the steam locomotive waterspout, the semaphore signal, the arriving westbound passenger train, the passengers on the station platform, and the interlocking tower, which protected the grade-level crossing with the Michigan Central Railroad. It is an outstanding photograph that would be difficult to top even with today's high-tech camera equipment. This book attempts to showcase the best Michigan railroad station images made by these pioneer photographers and arrange their work in a meaningful fashion. In addition, it will provide information about the communities and the railroads that served them.

Chapter 1, "Main Lines to Chicago," examines the stations of the five steam railroads that provided passenger service across Michigan (or parts of it) on their way to Chicago. They include the Grand Trunk, the Lake Shore & Michigan Southern Railway, the Michigan Central, the Pere Marquette, and the Wabash Railway. The railroad companies are arranged alphabetically within this chapter (and the other five chapters as well) and select depots on each of their routes are presented from east to west.

The second chapter, "Shortcut to Wisconsin," covers the three railroads that operated rail lines across Michigan, with connecting car ferry service to various Wisconsin points. Again the railroads are arranged alphabetically and the stations are arranged from east to west (southeast to northwest in the case of the Ann Arbor Railroad and Pere Marquette routes).

Chapter 3, "To the Northern Resorts," looks at the four railroads that provided accommodations to the resort areas of the northern Lower Peninsula. The stations illustrated for each company are presented from south to north.

With only a limited number of good postcards available from the Upper Peninsula and an extensive network of trackage, chapter 4, "Transforming the Upper Peninsula Wilderness," is a collection of images, which is simply arranged alphabetically by railroad and then alphabetically by station location.

A similar approach was taken with the fifth chapter, "Not Otherwise Accounted For," which illustrates a variety of Lower Peninsula branch line and secondary main line stations, where there was not enough material to make a meaningful line-by-line presentation.

In the first five chapters of the book, the perspective taken is that of the postcard era—roughly the period from 1910 to 1920. Much of train schedule information presented was taken from the July 1920 issue of the *Michigan Railway Guide*, as well as timetables issued by the individual railroads during this period.

Finally, chapter 6, "Two Spectacular Saves," takes a look at two Michigan railroad station masterpieces that recently have been authentically and lovingly restored to their original splendor. Michigan's glorious railroad past lives on in these marvelously restored structures.

8

One

MAIN LINES TO CHICAGO

Demand for travel across southern Michigan was brisk in the second decade of the 20th century. Five major steam railroads (the Grand Trunk Railway, the Lake Shore & Michigan Southern Railway, the Michigan Central Railroad, the Pere Marquette Railway, and the Wabash Railway) were all in competition with one another for the Chicago trade, particularly those originating in Detroit. In addition, several electric interurban carriers also offered competitive service in select southern Michigan markets.

The Grand Trunk provided service between Port Huron and Chicago, with through train service available to Toronto and Montreal. In addition, Detroit connections were available at Durand. Impressive depots were built at Port Huron, Flint, Durand, Lansing, and Battle Creek.

When the Michigan Southern Railroad (a successor of Michigan's first railroad, the Erie & Kalamazoo Railroad, and predecessor of the Lake Shore & Michigan Southern) operated its first through train between Toledo and Chicago in 1852, it followed a route across southern Michigan by way of Adrian and Hillsdale. This arrangement, however, was short-lived and ended when the Michigan Southern & Northern Indiana Rail Road (a Michigan Southern successor) completed its new "Air Line" across northern Ohio and Indiana. The Michigan Southern's original main line became known as the Old Road and continued to offer some passenger service between Toledo and Chicago. With the exception of large stations at Adrian and Hillsdale, most of the Old Road depots were modest structures and many were built to standard company design plans.

Of all the roads serving the Detroit-to-Chicago market, the Michigan Central was the premier carrier, operating the most trains and serving the largest population centers. The railroad described its stations as "buildings of manifest beauty and appropriateness" in an 1890 *Summer Tours* promotional brochure. Who could argue with that claim? The depots at Ann Arbor, Grass Lake, Battle Creek, Kalamazoo, and Niles were all buildings of unique and outstanding design.

The Pere Marquette's route between Detroit and Chicago by way of Grand Rapids was not exactly direct, and most of its depots were rather modest affairs, with the exception of the union station facilities at Detroit, Lansing, and Grand Rapids. Although, the railroad's stations at Lake Odessa and Holland both incorporated unique design elements.

Finally, the Wabash also offered competitive service in the Detroit-to-Chicago market, via Montpelier, Ohio; however, its strong suit was service between Detroit and St. Louis. Its main line ran only 80 miles across Michigan before pushing south into Ohio, but the railroad did build some ornately decorated, wood frame structures in several Michigan communities.

MAIN LINES TO CHICAGO

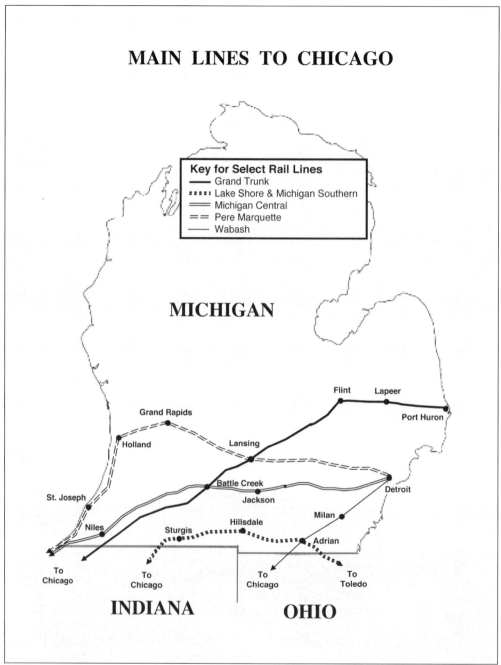

MAIN LINES TO CHICAGO. As the second decade of the 20th century dawned, competition was intense for customers traveling across southern Michigan to Chicago, particularly for those passengers beginning their journey in Detroit.

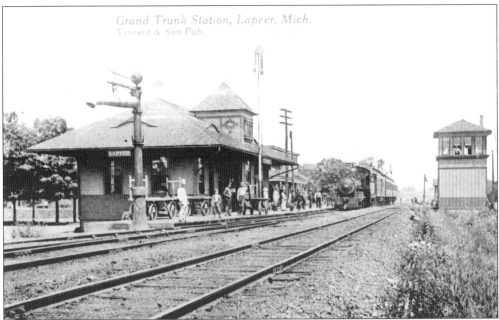

GRAND TRUNK DEPOT, LAPEER. Lapeer was located 43.9 miles west of Port Huron and was served by three railroads. The Port Huron & Lake Michigan Rail Road (a Grand Trunk Railway predecessor) was first to arrive in May 1871, followed by the Detroit & Bay City Railway (a Michigan Central Railroad predecessor) in November 1872, and the eight-mile Lapeer & Northern Railroad (owned by the Detroit & Bay City), which was completed to Five Lakes in 1876. (James Harlow collection.)

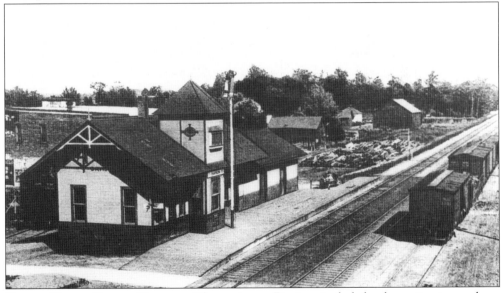

GRAND TRUNK DEPOT, DAVISON. The station at Davison included a decorative tower above the operator's bay window that was nearly identical to that used on the neighboring Lapeer depot. Both structures were built in 1900, with Lapeer receiving a hip roof and Davison using a gable design. To provide an extra measure of freight storage space, the station included a small addition on its eastern end. (James Harlow collection.)

11

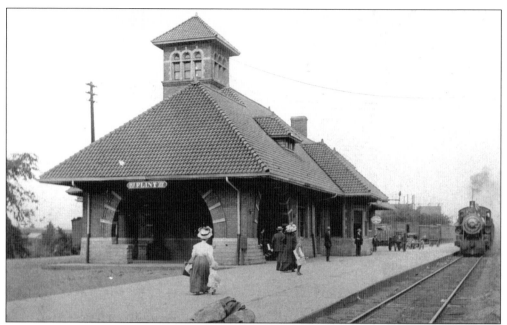

GRAND TRUNK DEPOT, FLINT. Flint was a major industrial center on the Grand Trunk Railway's Port Huron-to-Chicago main line and was given a large sandstone-and-brick station to serve passenger needs. The depot featured a compound hip roof, a street-side tower, and a tile roof. All 11 trains running on the main line made regularly scheduled stops at Flint according to the railroad's timetable dated June 27, 1920. (James Harlow collection.)

GRAND TRUNK DEPOT, LANSING. The Detroit architectural firm of Spier & Rohns won the design contracts in 1902 for both the Grand Trunk and the Lansing Union Station replacement projects. The Grand Trunk depot shown above featured a redbrick and limestone exterior with a 48-foot entrance tower. Inside, the station had an open timbered general waiting room, enameled brick wainscoting, and a mosaic tile floor. (James Harlow collection.)

12

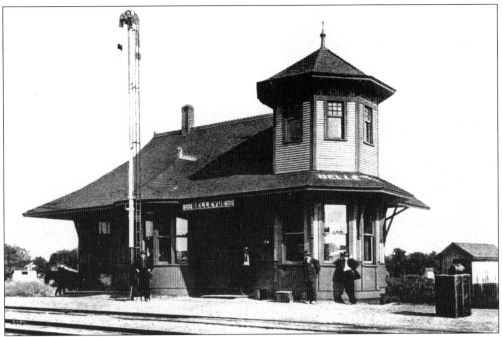

GRAND TRUNK DEPOT, BELLEVUE. Bellevue was located 31.7 miles west of Lansing and had one of the most beautiful wood frame stations on the entire Port Huron-to-Chicago line. The depot had a truncated hip roof design, with a small circular operator's bay window and dormer. An octagonal-shaped tower sat above the waiting room and served as the structure's focal point. (James Harlow collection.)

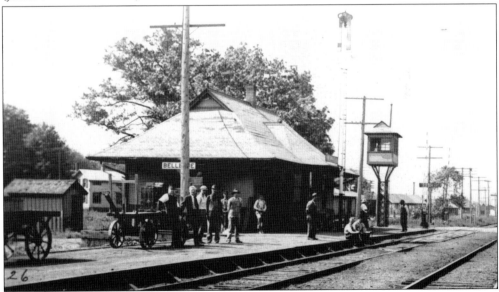

GRAND TRUNK REPLACEMENT DEPOT, BELLEVUE. Unfortunately, after a 1914 fire, the depot was rebuilt minus its ornate tower. Bellevue had a population of 1,200 residents in 1920, but travel options were somewhat limited from this location. In its June 1920 timetable, the Grand Trunk offered morning and afternoon service to Port Huron, plus a 12:15 p.m. train to Chicago, along with a 9:18 p.m. run to Battle Creek. (James Harlow collection.)

13

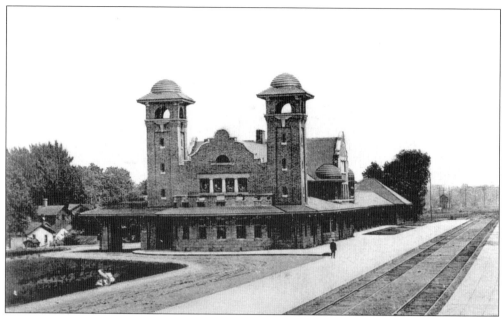

GRAND TRUNK DEPOT, BATTLE CREEK. If one tower made an attractive depot, would two towers make an even bolder design statement? Perhaps the Grand Trunk Railway was trying to top the Michigan Central Railroad when it provided preliminary design specifications for its new Battle Creek station. Completed in 1906, the Battle Creek depot featured twin towers capped by Hindu-style domes and a circular bay window done in granite. (James Harlow collection.)

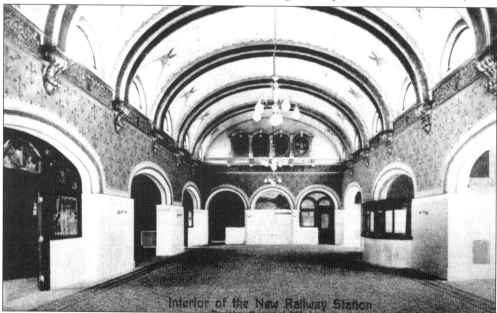

GRAND TRUNK DEPOT, INTERIOR, BATTLE CREEK. Interestingly, the architectural firm of Spier & Rohns, which had done several stations for the Michigan Central, was awarded the design contract by the Grand Trunk for its new Battle Creek depot. Once completed, the interior of the new station was just as impressive as its exterior. It featured vaulted ceilings, half-moon-shaped clerestory windows, white tile walls, and mosaic floors. (James Harlow collection.)

14

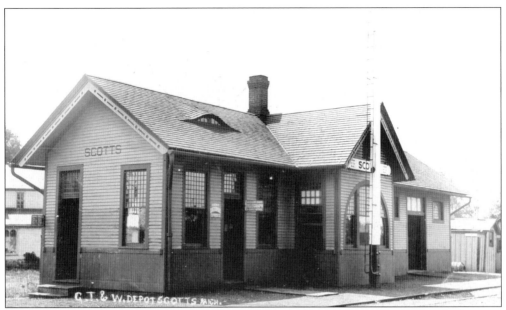

GRAND TRUNK DEPOT, SCOTTS. This community was originally known as Scotts Crossing and was named after Samuel Scott, one of its pioneer settlers. The Peninsular Railway arrived here in June 1871 and the following year, the community's name was shortened to Scotts. This wood frame station, with its ornate upper sash glass windowpanes, was located 15.7 miles west of Battle Creek. (James Harlow collection.)

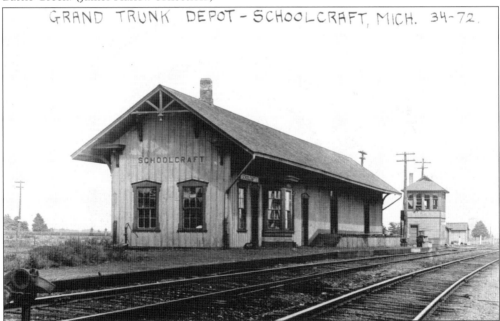

GRAND TRUNK DEPOT, SCHOOLCRAFT. Schoolcraft was served by two railroads, the Grand Trunk and the Lake Shore & Michigan Southern Railway's line from Elkhart, Indiana, to Grand Rapids. The junction sat immediately behind the wood frame Grand Trunk depot and the crossing was controlled by the interlocking tower at the right. In 1920, both railroads served the village with four trains each business day. (James Harlow collection.)

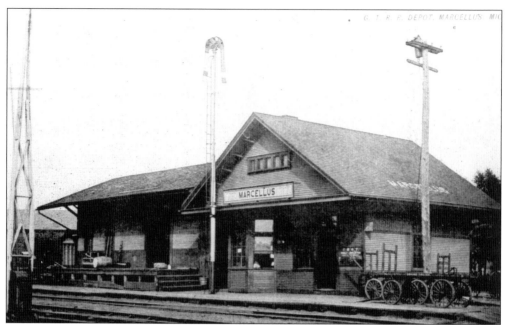

GRAND TRUNK DEPOT, MARCELLUS. When the Grand Trunk Railway built this wood frame station at Marcellus in 1902, it utilized one of its standard depot designs. This particular design plan was also used for the main line station at Bancroft, 113 miles to the east. The village of Marcellus was platted in 1870, with the intent that the Peninsular Railway pass diagonally through it. (James Harlow collection.)

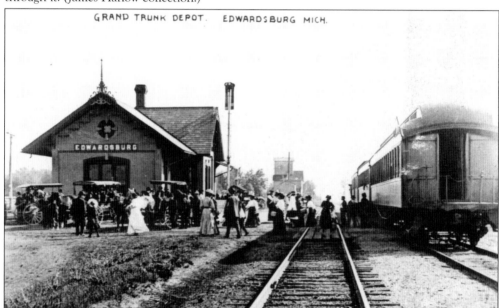

GRAND TRUNK DEPOT, EDWARDSBURG. Originally known as Beardsley's Prairie, Edwardsburg was renamed by the county's first merchant, Thomas Edwards. It was the last Grand Trunk station in Michigan and was located 2.9 rail miles from the Michigan/Indiana state line. Edwardsburg rated an attractive brick station building, which by 1920 was only serving 400 residents. (James Harlow collection.)

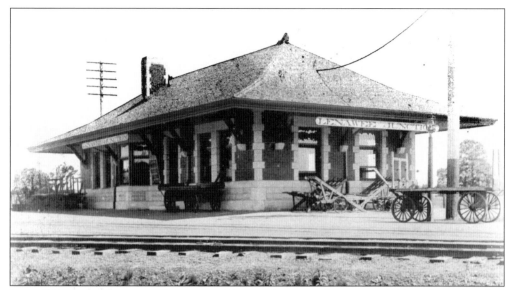

LAKE SHORE & MICHIGAN SOUTHERN DEPOT, LENAWEE JUNCTION. Although not listed in the *Michigan Railway Guide* town index, Lenawee Junction was nonetheless an important Lake Shore & Michigan Southern Railway operating location. The road's Toledo, Ohio, to Chicago, Illinois, main line through southern Michigan passed through this junction, located 4.1 miles northeast of Adrian. In addition, a branch line to Jackson and another to Monroe originated here. (Dave Tinder collection.)

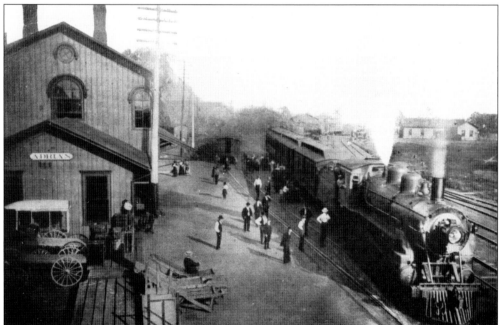

LAKE SHORE & MICHIGAN SOUTHERN DEPOT, ADRIAN. Adrian was located on Michigan's first railroad, the Erie & Kalamazoo Railroad (a Lake Shore & Michigan Southern predecessor). It initiated service on its rail line between Toledo, Ohio, and Adrian on November 2, 1836. The original Erie & Kalamazoo line between Palmyra Junction and Adrian was later abandoned, and traffic was routed to Adrian via Lenawee Junction. (James Harlow collection.)

17

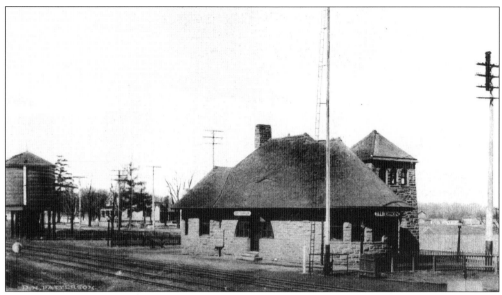

LAKE SHORE & MICHIGAN SOUTHERN DEPOT, HUDSON. Hudson was served by two railroads—the Lake Shore & Michigan Southern Railway and the Cincinnati Northern Railroad. The Lake Shore's stone depot, designed by Spier & Rohns, was a first-class facility and stood in sharp contrast to the Cincinnati Northern's rambling wood frame station. There was no traffic interchanged between the two railroads at this location. (James Harlow collection.)

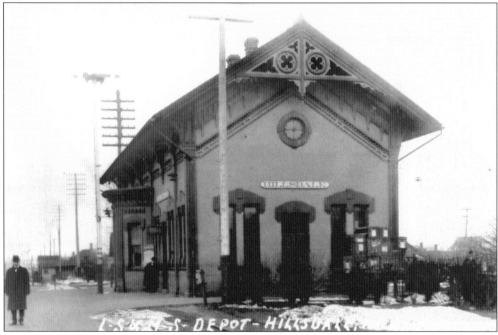

LAKE SHORE & MICHIGAN SOUTHERN DEPOT, HILLSDALE. In the summer of 1920, Hillsdale's brick station played host to 20 New York Central Railroad trains each business day, operating on four different timetable routes. Six trains were scheduled on both the Old Road and the branch from Jackson to Fort Wayne, Indiana. In addition, there were four scheduled trains between Ypsilanti and Hillsdale and four between Lansing and Hillsdale. (James Harlow collection.)

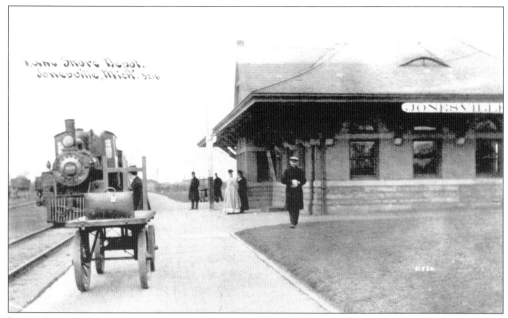

LAKE SHORE & MICHIGAN SOUTHERN DEPOT, JONESVILLE. Jonesville was served by three rail lines, completed between September 1850 and January 1872, and they utilized two separate stations. The Old Road and the Lansing Branch, the first and last lines to arrive in Jonesville, used the replacement station pictured above. The Fort Wayne Branch was completed through town in November 1869 and used a separate depot. (James Harlow collection.)

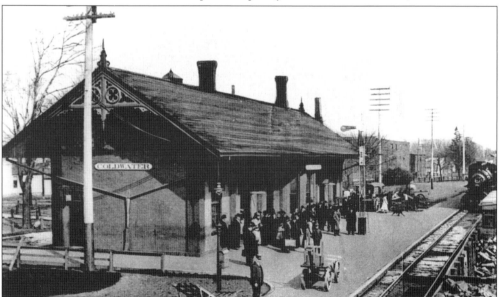

LAKE SHORE & MICHIGAN SOUTHERN DEPOT, COLDWATER. The Michigan Southern Railroad (a Lake Shore & Michigan Southern predecessor) completed its main line as far as Coldwater in December 1850. Thirty-three years later, the Lake Shore & Michigan Southern built this attractive brick replacement station to serve the community. In the view above, a large number of people are gathered on the station platform as a westbound train approaches. (James Harlow collection.)

19

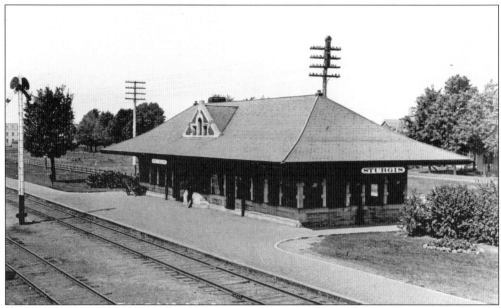

LAKE SHORE & MICHIGAN SOUTHERN DEPOT, STURGIS. The Michigan Southern Railroad completed its main line through Sturgis in July 1851. The community was also served by the Grand Rapids & Indiana Railroad and a split ownership branch line running between Battle Creek and Goshen, Indiana. The Michigan Central Railroad leased the branch north of Findley (7.3 miles north of Sturgis) and the Lake Shore & Michigan Southern Railway leased it south of that point. (James Harlow collection.)

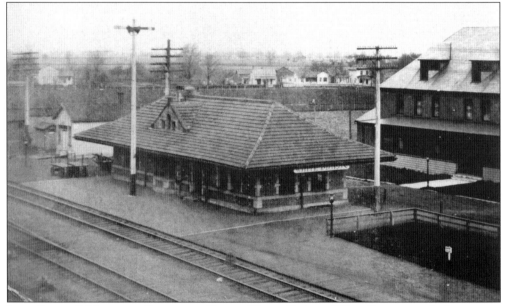

LAKE SHORE & MICHIGAN SOUTHERN DEPOT, WHITE PIGEON. White Pigeon was the last station stop in Michigan before the Lake Shore & Michigan Southern main line headed southwest into Indiana and ultimately to Chicago, Illinois. In addition to five main line trains (two eastbound and three westbound), the community was also served by four trains on the Elkhart, Indiana, to Grand Rapids line each business day in July 1920. (James Harlow collection.)

20

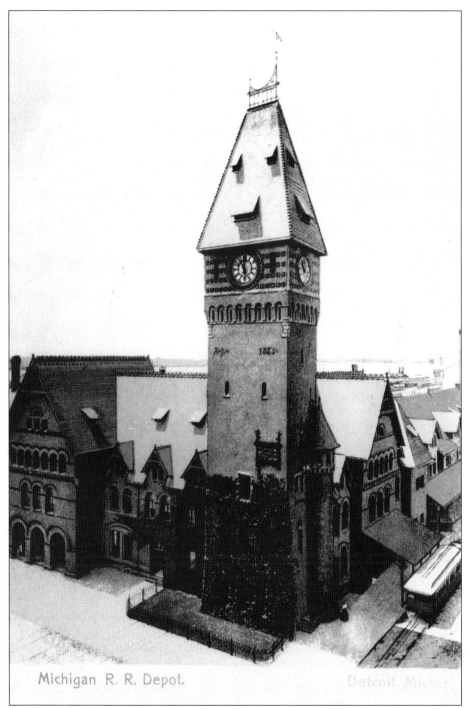

Michigan R. R. Depot. Detroit, Mich.

MICHIGAN CENTRAL DEPOT, THIRD STREET, DETROIT. Designed by Cyrus Eidlitz, the Michigan Central's Third Street Station in Detroit was an impressive structure when completed in 1883. Unfortunately, the lifespan of this stub-end terminal was cut short by the railroad's decision to build a tunnel under the Detroit River, eliminating the time-consuming car ferry operation between Detroit and Windsor, Ontario. (James Harlow collection.)

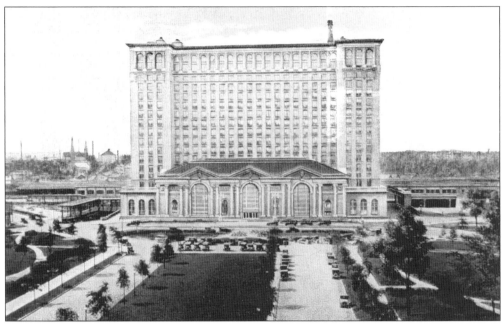

MICHIGAN CENTRAL DEPOT AND ROOSEVELT PARK, DETROIT. The new Detroit station was located south of Michigan Avenue between Fifteenth and Twenty-first Streets, two miles west of the central business district, but perfectly aligned with the western portal of the Detroit River Tunnel. It was a $16 million project—$9 million for the tunnel, $4.5 million for the yards and support structures, and $2.5 million for the station office building. (James Harlow collection.)

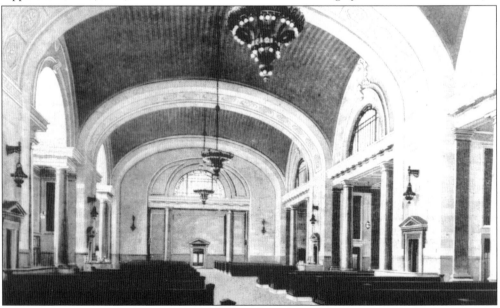

MICHIGAN CENTRAL DEPOT, WAITING ROOM, DETROIT. Grand opening ceremonies for the new station, with its elegant 76-foot-high waiting room ceiling, were scheduled for Sunday, January 4, 1914. However, an afternoon fire at the Third Street Station on December 26, 1913, changed those plans. The decision was made to immediately move operations to the new station, and at 5:20 p.m., the first train departed for Saginaw and Bay City. (James Harlow collection.)

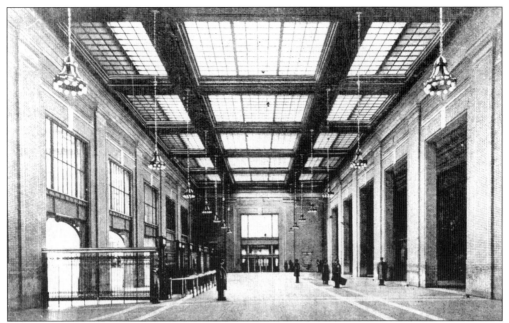

MICHIGAN CENTRAL DEPOT, CONCOURSE, DETROIT. The architectural firms of Reed & Stem and Warren & Wetmore collaborated on the design of the new Detroit station and office building. They were the same architects that created Grand Central Terminal in New York City. Skylights were used to help illuminate the concourse area, which was linked to the main waiting room through an arcade of ticket windows. (James Harlow collection.)

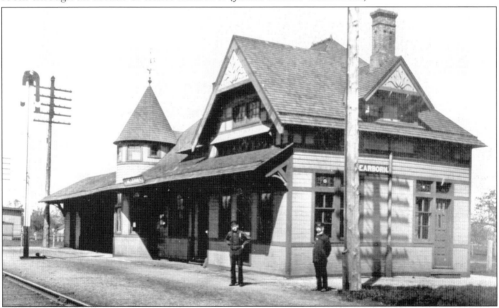

MICHIGAN CENTRAL DEPOT, DEARBORN. Dearborn was the first station stop west of Detroit. According to the railroad's timetable dated June 27, 1920, most of the Detroit-to-Chicago trains passed through town without stopping. Eastbound train Nos. 2, 6, and 12 stopped in Dearborn, while train Nos. 5 and 11 were the only westbounds to pause. The station, built in 1898, sported a unique conical dome above the ticket agent's bay window. (James Harlow collection.)

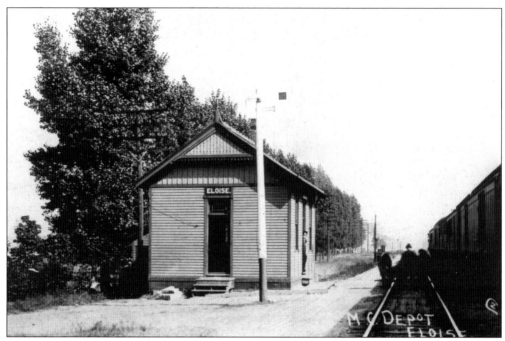

MICHIGAN CENTRAL DEPOT, ELOISE. Located 13.8 miles west of Detroit, Eloise escaped mention in the July 1920 *Michigan Railway Guide.* More complete information, however, could be found in the railroad's own timetable dated March 9, 1919, which showed Eloise as a conditional stop for train Nos. 2, 12, and 19. Train No. 5 was the only one making a scheduled stop here. Eloise was home to Wayne County's infirmary, sanitarium, and hospital. (James Harlow collection.)

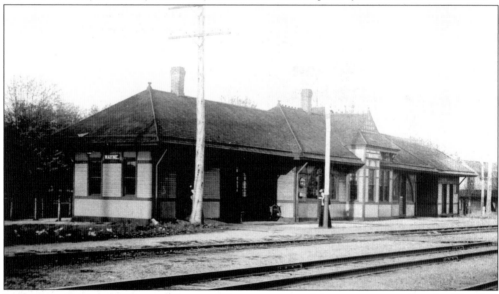

MICHIGAN CENTRAL DEPOT, WAYNE. Wayne was served by two steam railroads. The first line to arrive was completed by the State of Michigan in February 1838 and was subsequently purchased by the Michigan Central Railroad. Thirty-three years later, the Holly, Wayne & Monroe Railway (a Pere Marquette Railway predecessor) arrived in Wayne, and a complete line between Saginaw and Toledo, Ohio, was in place by January 1872. (James Harlow collection.)

24

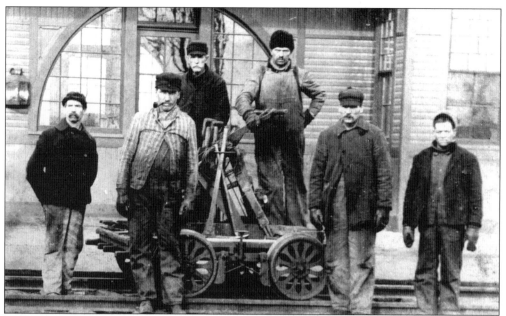

MICHIGAN CENTRAL TRACK MAINTENANCE CREW, WAYNE. The Michigan Central was always the dominant player in Wayne. Although both companies maintained wood frame depots here, the Michigan Central's station was definitely a cut above the Pere Marquette's depot. A Michigan Central track maintenance crew poses with its handcar in front of the waiting room door. (James Harlow collection.)

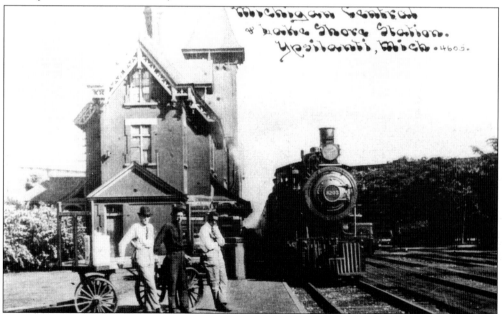

MICHIGAN CENTRAL DEPOT, YPSILANTI. Ypsilanti was served by two steam railroads, the Michigan Central and the Detroit, Hillsdale & Indiana Rail Road. The state-owned central railroad project arrived first in February 1838, while construction on the Detroit, Hillsdale & Indiana line did not begin until July 1871. The line to Hillsdale was completed early the following year. Both railroads used the Michigan Central depot shown above. (James Harlow collection.)

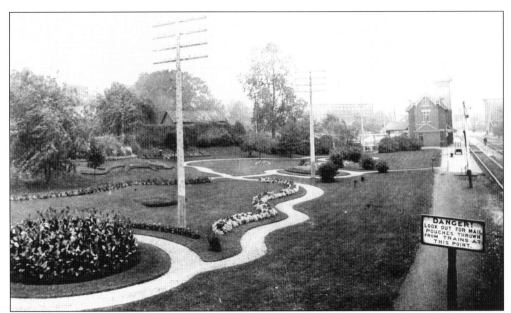

MICHIGAN CENTRAL DEPOT PARK, YPSILANTI. The Michigan Central Railroad owned greenhouses here and at Niles where flowers were raised and used in the railroad's dining cars. Fresh flowers were also supplied to the restaurant in the new Michigan Central depot in Detroit. The dining room in the Detroit station was a very elegant facility at that time. (James Harlow collection.)

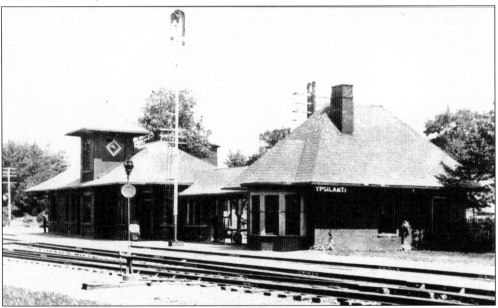

MICHIGAN CENTRAL RECONFIGURED DEPOT, YPSILANTI. On May 28, 1910, a fire destroyed the upper floors of the station. After its reconstruction, the depot took on a less ornate appearance, but Ypsilanti remained a busy railroad town. According to its June 1920 timetables, the Michigan Central had 17 passenger trains making regularly scheduled stops each business day. On the New York Central Railroad, there were two trains each way running between Ypsilanti and Hillsdale. (James Harlow collection.)

26

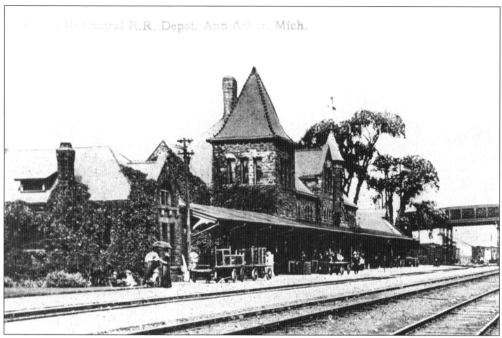

MICHIGAN CENTRAL DEPOT, ANN ARBOR. The Detroit architectural firm of Spier & Rohns was given the contract to design a replacement station for the Michigan Central in Ann Arbor. The Romanesque-style station was completed in 1886 and featured massive stone walls, a short tower and turret along its trackside facade, and a fireplace in the main waiting room. (James Harlow collection.)

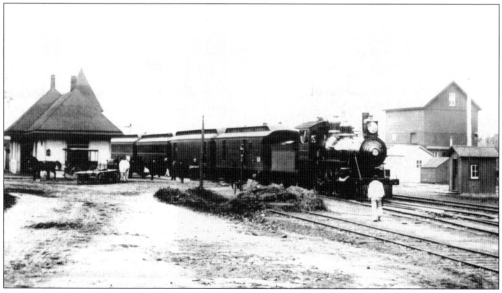

MICHIGAN CENTRAL DEPOT, DEXTER. There was even more reason for jubilation in Dexter on July 4, 1841, since the state-owned railroad had completed its line from Detroit just five days earlier. The community, named after Judge Samuel Dexter, has been served by this attractive wood frame depot since January 1887. It featured an interesting tower above the operator's trackside bay window. (James Harlow collection.)

27

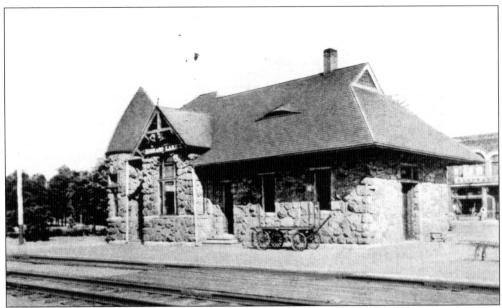

MICHIGAN CENTRAL DEPOT, GRASS LAKE. When the Michigan Central Railroad elected to replace the depot at Grass Lake in 1886, it contracted with the architectural firm of Spier & Rohns in Detroit for a design. Stone for the new depot was quarried northwest of Ann Arbor and was shipped by rail to Grass Lake. Work on the station commenced in August 1887 and was completed that December. (James Harlow collection.)

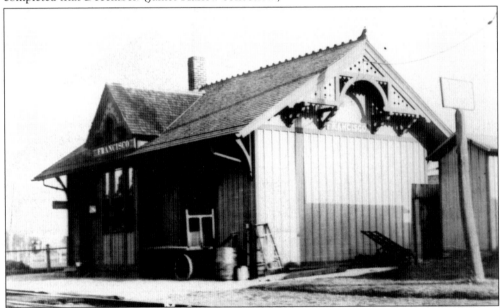

MICHIGAN CENTRAL DEPOT, FRANCISCO. Located 14.4 miles east of Jackson, Francisco was served by the Michigan Central and the Detroit United Railway in June 1920. Service was limited on the Michigan Central, with only two trains making regularly scheduled stops and two others being scheduled as flag stops. For those making shorter trips, the Detroit United offered more frequent service to Detroit and Kalamazoo from Francisco on its electric interurban cars. (James Harlow collection.)

28

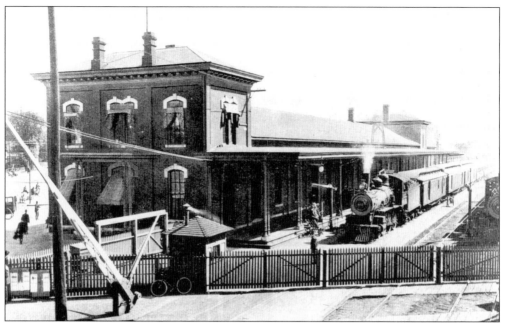

MICHIGAN CENTRAL DEPOT, JACKSON. Jackson was an important railroad town, with steam railroad lines radiating out of the city in eight different directions. The large, redbrick, Italianate-style structure served not only as a station but also housed the Michigan Central's Middle Division train dispatchers. At the west end of the depot, a gatekeeper was employed to operate the fences that stretched across the tracks. (James Harlow collection.)

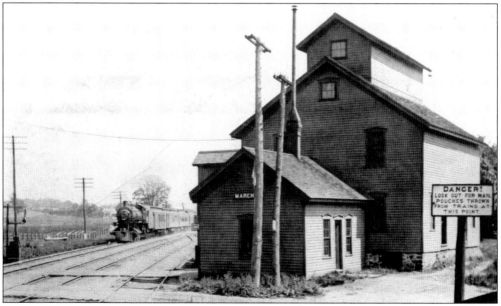

MICHIGAN CENTRAL DEPOT, MARENGO. At its first town meeting in 1833, this community elected to name itself after Napoleon's horse at the Battle of Waterloo. Marengo was located 25.6 miles west of Jackson, and in the summer of 1920, the village was served by both the Michigan Central and the electric cars of the Michigan Railway. Above, a westbound Michigan Central train is shown passing the station at Marengo. (James Harlow collection.)

29

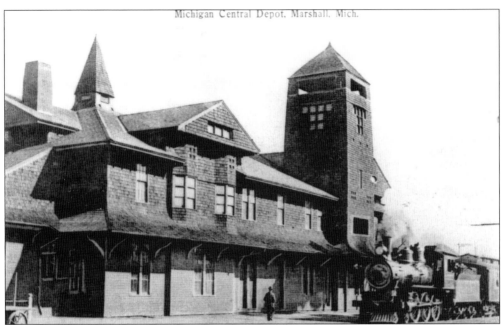

Michigan Central Depot, Marshall, Mich.

MICHIGAN CENTRAL DEPOT, MARSHALL. The state's central railroad project was completed to Marshall in August 1844, despite continuing difficulty paying bond interest and the construction contractors for their work. Actually, the year before, the state legislature recognized that there were no additional avenues for raising money and ordered that the central line be completed only as far as Kalamazoo. (James Harlow collection.)

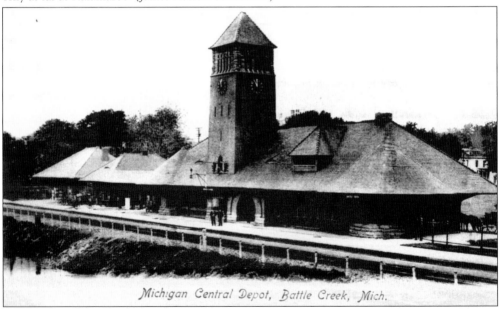

Michigan Central Depot, Battle Creek, Mich.

MICHIGAN CENTRAL DEPOT, BATTLE CREEK. The Detroit architectural firm of Rogers & MacFarlane designed this Michigan Central Railroad replacement station at Battle Creek, which was completed in 1888. It was built of Lake Superior red stone and Detroit red brick, and was capped with an Akron red tile roof. Proud local citizens were quick to point out that their depot was 30 feet longer than the station at Kalamazoo. (James Harlow collection.)

30

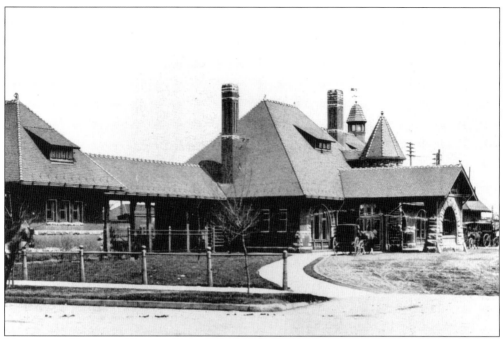

MICHIGAN CENTRAL DEPOT, KALAMAZOO. Architect Cyrus Eidlitz elected to use brick, terra-cotta, and brownstone for the new Kalamazoo depot in 1887. His creation was an interesting blend of the Romanesque and classic villa styles. The waiting rooms featured tiled fireplaces and stained-glass windows. Eidlitz also designed the 1883 Michigan Central Third Street Station in Detroit and the 1885 Dearborn Street Station in Chicago. (James Harlow collection.)

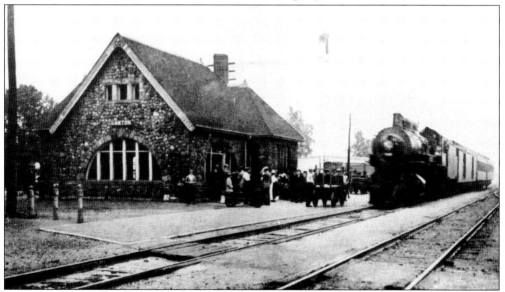

MICHIGAN CENTRAL DEPOT, LAWTON. Pleased with its 1889 Northern Division station at Standish, the railroad elected to use the design again on its Middle Division depot at Lawton. The elegant fieldstone structure featured a large half-moon-shaped window grouping in the waiting room and surrounding its trackside entranceway. A westbound train is shown approaching Lawton, with a large crowd of passengers waiting on the platform. (James Harlow collection.)

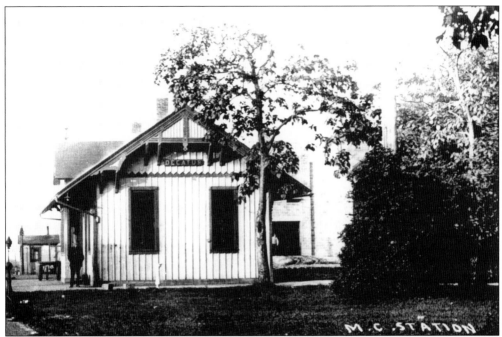

MICHIGAN CENTRAL DEPOT, DECATUR. The state sold its central railroad project in September 1846 to a group of investors for $2 million. The new company would be known as the Michigan Central Railroad and was given three years to complete the line from Kalamazoo to Lake Michigan. No new trackage was added in 1847, but the line between Kalamazoo and Niles via Decatur was completed in October 1848. (James Harlow collection.)

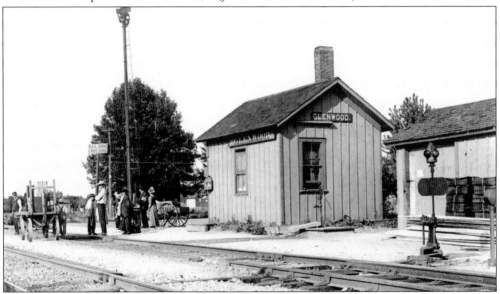

MICHIGAN CENTRAL DEPOT, GLENWOOD. With a 1920 population of only 120, Glenwood rated only a small wood frame station to serve its residents. Equally miniscule were the travel options from this location. According to its timetable dated June 27, 1920, only three Michigan Central trains made regularly scheduled stops here, with three other trains scheduled to make flag stops. (Dave Tinder collection.)

32

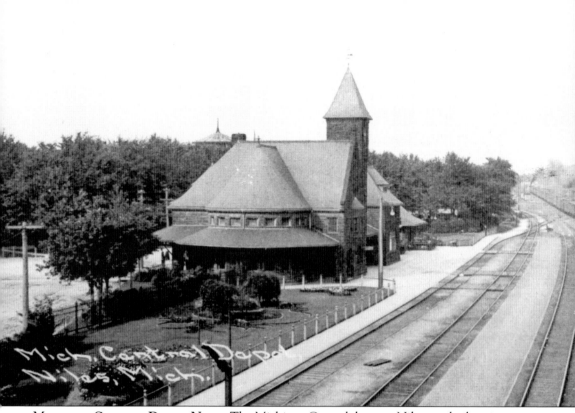

MICHIGAN CENTRAL DEPOT, NILES. The Michigan Central depot at Niles was built to impress passengers and the general public when it opened in 1892. Passengers traveling on the Michigan Central in 1893 to the World's Columbian Exposition in Chicago would marvel as they paused at the massive depot and beautifully landscaped grounds. Train schedules allowed time for passengers to detrain and briefly stroll the station grounds. The architectural firm of Spier & Rohns in Detroit was responsible for the stunning Romanesque design, which featured Ohio brownstone walls and a 68-foot clock tower. The three lighted clock faces were five feet in diameter. Landscape architect John Gipner created impressive gardens, with "Niles" spelled out in flowers each spring. In addition, he installed a floating garden, a trout pond, and a gazebo and built greenhouses on the grounds. The greenhouses east of the depot supplied flowers for the railroad's dining cars and to the restaurant in the station. Gipner reportedly also began the practice of passing out flowers or small bouquets to all female passengers. (James Harlow collection.)

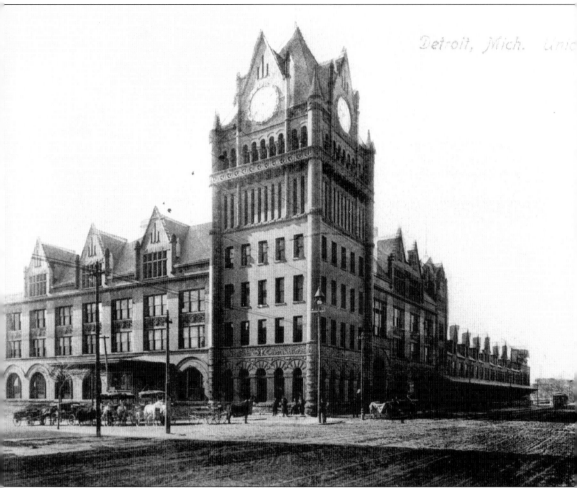

FORT STREET UNION DEPOT, DETROIT. The idea for a union depot was conceived by Detroit business leader James Joy, and in 1890, the Canadian Pacific Railway, Detroit, Lansing & Northern Railroad, Flint & Pere Marquette Railroad, and Wabash Railroad formed the Fort Street Union Depot Company. James Stewart & Company designed the structure, which was a unique blend of Romanesque arches and squared-off upper-floor window openings. A massive clock tower was the building's focal point. Grand opening ceremonies were held on Saturday, January 21, 1893, and newspaper accounts estimated that 10,000 people visited the depot that day, including out-of-town guests from Saginaw brought down on a special Flint & Pere Marquette train. Adding to the festive atmosphere was the 19th Infantry Regiment Band, which played from the gallery overlooking the waiting room. The first regularly scheduled train to use the depot arrived the following day, when Flint & Pere Marquette train No. 10 arrived from Bay City early Sunday morning. (James Harlow collection.)

34

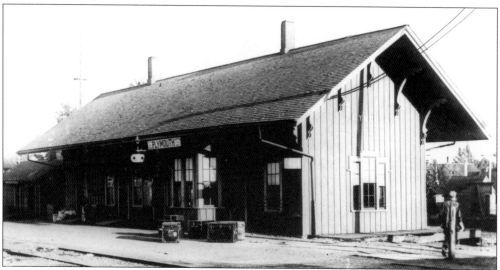

PERE MARQUETTE DEPOT, PLYMOUTH. Plymouth has been an important railroad junction since 1871, when the Holly, Wayne & Monroe Railway arrived here from Saginaw that May, and the Detroit, Lansing & Lake Michigan Railroad a month later. Both companies eventually wound up as part of the Pere Marquette Railroad in 1899. This wood frame station served the Detroit-to-Grand Rapids line, built by the Detroit, Lansing & Lake Michigan. (James Harlow collection.)

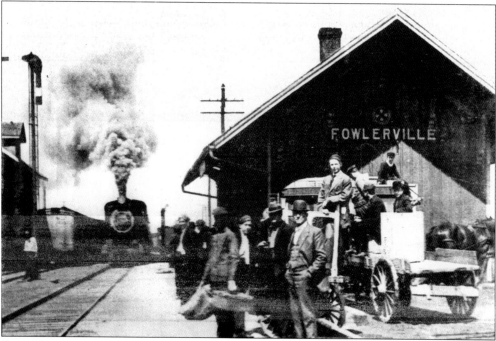

PERE MARQUETTE DEPOT, FOWLERVILLE. While the Pere Marquette may not have been the best way to get from Detroit to Chicago, it did offer fairly close connections for those traveling beyond Grand Rapids. In June 1920, train No. 5 left Fowlerville at 2:28 p.m. and arrived in Grand Rapids at 4:50 p.m. The connecting Grand Rapids-to-Chicago train left at 5:15 p.m., with a 10:15 p.m. arrival at Grand Central Station. (James Harlow collection.)

35

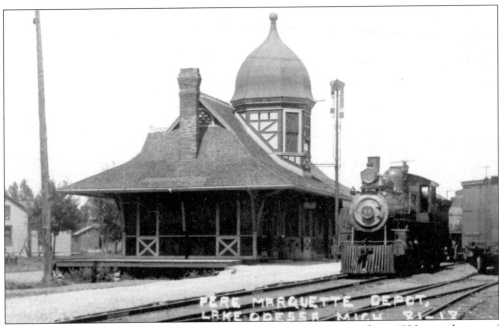

PERE MARQUETTE DEPOT, LAKE ODESSA. For a community with a 1920 population of 1,400 residents, Lake Odessa was served well by the Pere Marquette Railway. Eight passenger trains called on the station each business day. Built by the Detroit, Lansing & Northern Railroad (a Pere Marquette predecessor) in 1890, the Lake Odessa depot was unique with its onion-shaped dome and bell-cast hip roof. (James Harlow collection.)

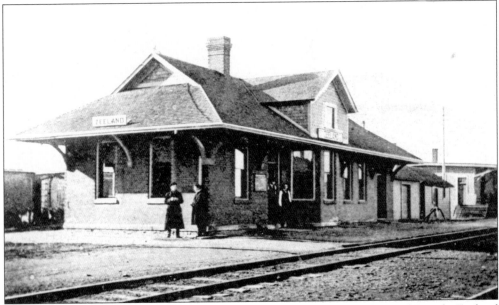

PERE MARQUETTE DEPOT, ZEELAND. Located 20.7 miles southwest of Grand Rapids, Zeeland was served by the steam trains of the Pere Marquette and the electric interurban cars of the Michigan Railway. According to its timetables dated June 6, 1920, the Pere Marquette offered Zeeland residents six departures each business day—three to Grand Rapids and three to Chicago. (James Harlow collection.)

36

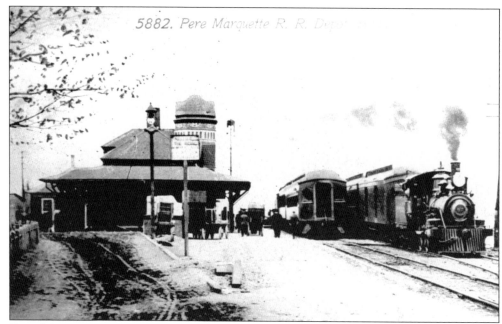

PERE MARQUETTE DEPOT, HOLLAND. Holland was an important Pere Marquette junction in southwest Michigan. It was a station on both the Grand Rapids–Chicago line and the Allegan–Pentwater line. In June 1920, there were six departures for Chicago, six for Grand Rapids, three for Pentwater, and one for Allegan each business day. In addition, there were three trains arriving from Pentwater and one from Allegan. (James Harlow collection.)

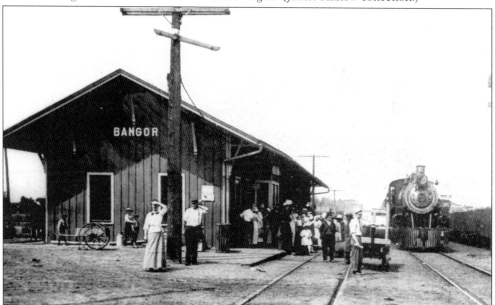

PERE MARQUETTE DEPOT, BANGOR. The Chicago & Michigan Lake Shore Railroad (a Pere Marquette predecessor) completed its rail line through Bangor (60.6 miles southwest of Grand Rapids) in February 1871, and the community was served by this wood frame depot during the postcard era. First platted in 1860, the village was not formally incorporated until 1877. It was named after Bangor, Maine. (James Harlow collection.)

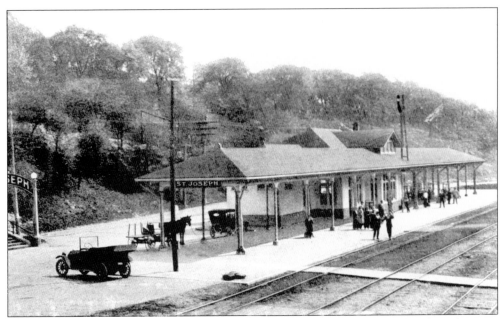

PERE MARQUETTE DEPOT, ST. JOSEPH. The Pere Marquette Railroad replaced its depot in St. Joseph in 1913 with this attractive structure on the shores of Lake Michigan. As passengers got off the train, the depot park and the lake were their first views. For those staying overnight in this resort community, the Whitcomb Hotel and Mineral Baths offered rooms with private baths and telephones starting at $2.50 a night in June 1920. (James Harlow collection.)

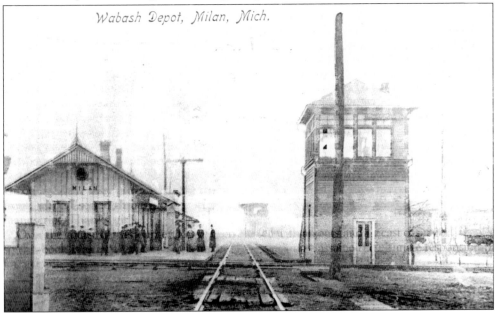

WABASH DEPOT, MILAN. This Monroe County community witnessed a second flurry of railroad construction activity in 1881, when the Detroit, Butler & St. Louis Railroad (a Wabash Railroad predecessor) was finishing up its route between Detroit and Butler, Indiana. Milan was already being served by the Toledo & Ann Arbor Railroad (an Ann Arbor Railroad predecessor), which had completed a line between its namesake cities in May 1878. (James Harlow collection.)

38

Two

SHORTCUT TO WISCONSIN

As Chicago grew in importance as a midwestern rail hub, it also took on the unenviable reputation of being a traffic bottleneck for rail shipments attempting to move through the city's maze of trackage. In 1892, the Toledo, Ann Arbor & North Michigan Railway (an Ann Arbor Railroad predecessor) began offering car ferry service across Lake Michigan from its Elberta terminal, as a less costly and time-saving route avoiding Chicago. The wooden hulled, steel-reinforced car ferries *Ann Arbor Number 1* and *Ann Arbor Number 2* were each capable of carrying 24 freight cars on four deck tracks, and were designed for a speed of 14 knots. During most of its history, passenger trains played a secondary role in the company's operations, although in 1911, the Ann Arbor did purchase five McKeen motor cars in an effort to improve service and trim expenses. As a result, most of the Ann Arbor's depots were modest wood frame structures, although its brick depots at Howell, Owosso, and Cadillac were very attractive buildings.

While the Toledo, Ann Arbor & North Michigan was the first to offer car ferry service, it was the Pere Marquette Railway that ultimately became the largest operator of railroad car ferries on Lake Michigan. Five years after the Ann Arbor boats were placed in service, the Flint & Pere Marquette Railroad (a Pere Marquette predecessor) had a steel hulled car ferry built for use out of its Ludington terminal. The new car ferry *Pere Marquette* had superior ice-breaking capabilities and provided the railroad with a year-round route for through traffic across Michigan—a route that it was eager to develop in light of diminishing lumber revenues being generated locally. Like the Ann Arbor, the Pere Marquette's line from Toledo and Detroit to Ludington offered only modest passenger service. The depots at Flint and Saginaw were, without question, the most impressive stations on the line, although visually pleasing structures also existed at Holly, Clare, and Reed City.

Given the success of the Ann Arbor and Pere Marquette car ferry service, the Grand Trunk Railway established a car ferry shortcut route of its own in 1903, between Grand Haven and Milwaukee, Wisconsin. The railroad's Detroit-to-Grand Haven line was home to four of the five uniquely styled "witch's hat" depots, which were located at Clarkston, Corunna, Fowler, and Saranac. In 1933, the Grand Trunk Western Railroad (a Grand Trunk successor) moved its car ferry terminal from Grand Haven to Muskegon to take advantage of a more easily navigated harbor.

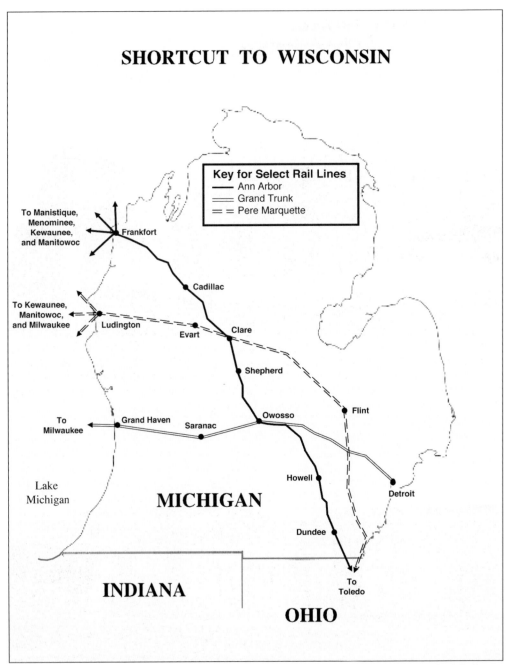

SHORTCUT TO WISCONSIN

Key for Select Rail Lines
— Ann Arbor
═ Grand Trunk
= = Pere Marquette

SHORTCUT TO WISCONSIN. The three railroads offering car ferry service across Lake Michigan marketed themselves as time-saving alternatives to Chicago area rail congestion.

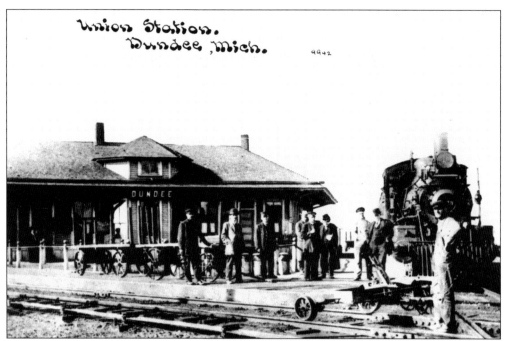

UNION DEPOT, DUNDEE. Dundee was located 22.8 miles north of Cherry Street Station in Toledo, Ohio, and was an important stop on the Ann Arbor Railroad. In June 1920, all 10 of its weekday trains stopped to pick up or drop off passengers here. In addition, Dundee was also served by the four passenger trains on the Detroit, Toledo & Ironton Railroad and by four more on the New York Central Railroad. (James Harlow collection.)

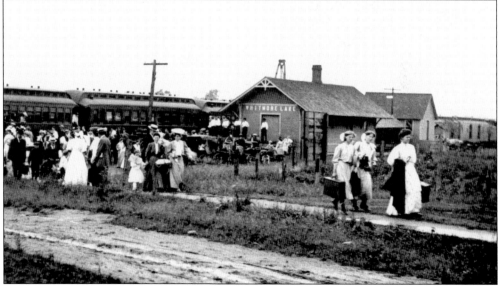

ANN ARBOR DEPOT, WHITMORE LAKE. The railroad's summer timetables in 1920 made it easy for Ann Arbor residents to board motor train No. 13 at 11:56 a.m. for a day of swimming or relaxing at Whitmore Lake, eight miles to the north. After an afternoon of fun in the sun, train No. 52, a conventional locomotive-hauled train, left Whitmore Lake for Ann Arbor at 4:16 p.m. (James Harlow collection.)

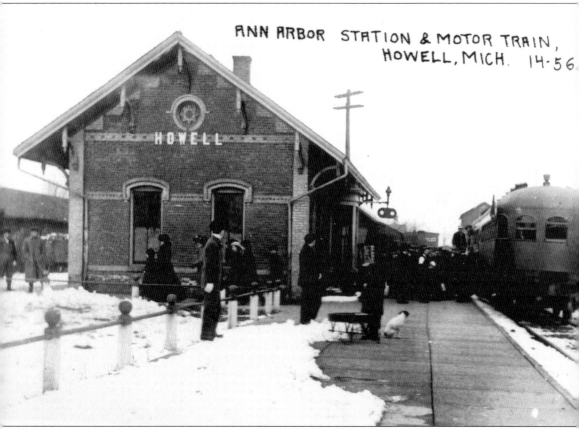

ANN ARBOR DEPOT, HOWELL. The Detroit, Lansing & Lake Michigan Railroad was the first railroad to reach Howell from Detroit in 1871. Its residents, however, lobbied for a second rail line by offering the Toledo, Ann Arbor & North Michigan Railway $20,000 to build through town. Their efforts were rewarded when the company accepted Howell's offer. Construction progressed smoothly until the Toledo, Ann Arbor & North Michigan attempted to install a crossing over the Detroit, Lansing & Lake Michigan southeast of town in 1886. The crossing dispute was mediated in favor of the Toledo, Ann Arbor & North Michigan, and a diamond was installed at a place called Howell Junction. The crossing was renamed Annpere in 1906 after the names of the two successor railroads—the Ann Arbor Railroad and the Pere Marquette Railroad. In the fall of 1886, the Toledo, Ann Arbor & North Michigan built an attractive brick station, which featured two contrasting shades of brick, circular attic windows in the end walls, and curved brackets under the eaves. (Dave Tinder collection.)

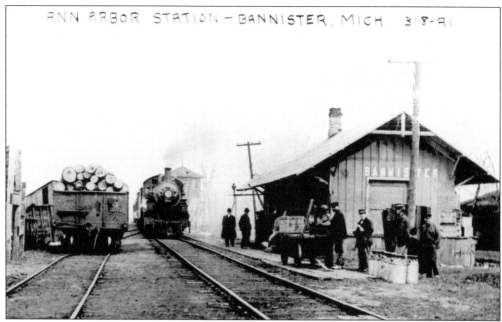

ANN ARBOR DEPOT, BANNISTER. Bannister was located 16.7 miles north of Owosso and was named after an early settler, Asahel Bannister of Jackson. The Toledo, Ann Arbor & North Michigan (an Ann Arbor predecessor) completed this portion of the line in June 1884. The line saw increased rail traffic in 1887, when trains of the Toledo, Saginaw & Muskegon Railway (a Grand Trunk Railway predecessor) began sharing the tracks through Bannister. (James Harlow collection.)

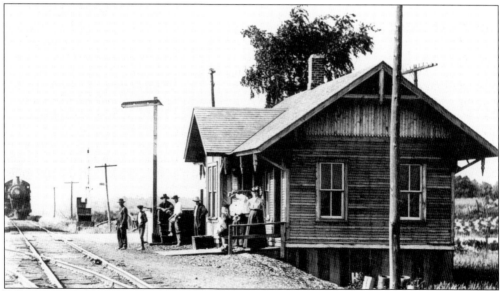

ANN ARBOR DEPOT, FOREST HILL. When originally platted in 1857, Forest Hill was so named because the area was heavily timbered and sat on ground higher than that surrounding it. When an improved road passed nearby, the village migrated to that location, where there was neither forest nor hill. The Toledo, Ann Arbor & North Michigan (an Ann Arbor predecessor) completed its line through Forest Hill in 1885. (James Harlow collection.)

43

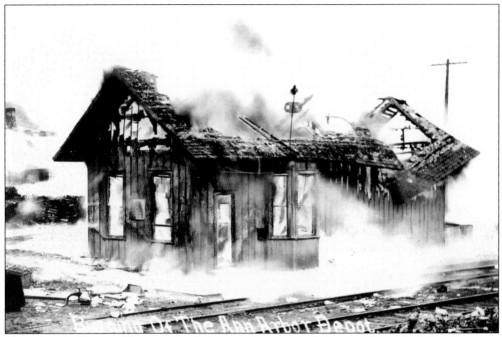

ANN ARBOR DEPOT, TEMPLE. By the time volunteer firefighters extinguished the flames on March 15, 1910, the Ann Arbor Railroad depot at Temple was a total loss. A photographer at the scene captured the blaze on film just before the roof section above the freight room collapsed. While strange by today's standards, this tragic event was made into a postcard and sold locally. (Dave Tinder collection.)

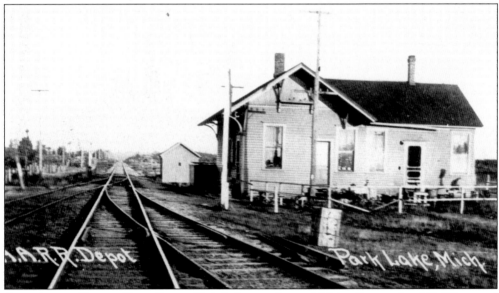

ANN ARBOR DEPOT, PARK LAKE. Park Lake was located 14.4 miles south of Cadillac, and despite its 1920 population of only 300, this small community was served by four motor trains each business day, plus a daily-except-Saturday overnight train to Toledo. Recognizing that housing was limited in Park Lake, the Ann Arbor provided living quarters for the station agent and his family at the back of the station. (James Harlow collection.)

44

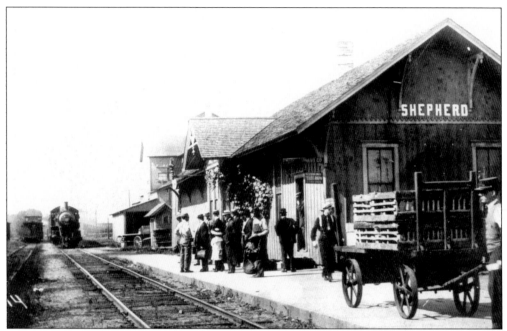

ANN ARBOR DEPOT, SHEPHERD. In addition to its motor car trains, the Ann Arbor ran six conventional locomotive-hauled trains, giving Shepherd residents a choice of 10 weekday departures in June 1920. On Sundays, the railroad ran a train between Mount Pleasant and Toledo. It departed Shepherd at 6:17 a.m. and arrived in Toledo at 12:05 p.m. The returning northbound trip left Toledo at 5:00 p.m. and arrived back in Shepherd at 11:08 p.m. (James Harlow collection.)

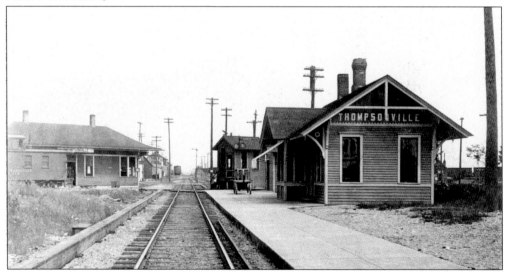

ANN ARBOR DEPOT, THOMPSONVILLE. Thompsonville marked the spot where the Ann Arbor's Toledo–Frankfort line crossed the Pere Marquette Railway's Grand Rapids–Bay View line. The Frankfort & South Eastern Railroad (an Ann Arbor predecessor) was the first to arrive in Thompsonville in 1889, while the Chicago & West Michigan Railway (a Pere Marquette predecessor) completed its line through town the following year. Each company maintained separate station facilities. (James Harlow collection.)

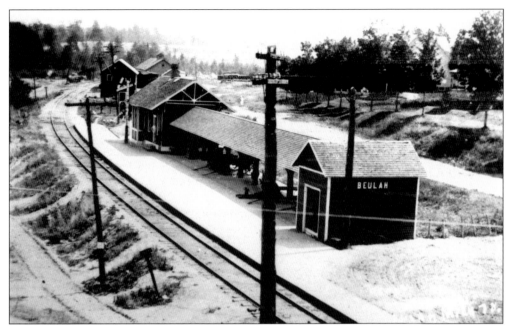

ANN ARBOR DEPOT, BEULAH. Beulah was a small community of 400 residents in 1920 and was located 9.4 miles east of Frankfort on the shores of Crystal Lake. It was a resort destination in itself, and the Ann Arbor Railroad maintained an attractive wood frame depot there. The station featured a large covered outdoor waiting area, which ran parallel to the boarding platform. (James Harlow collection.)

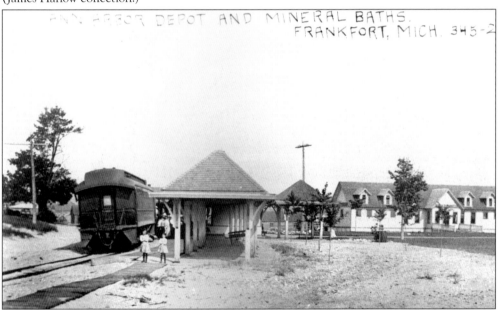

ANN ARBOR DEPOT, FRANKFORT. The Frankfort station and the Ann Arbor's 100-room Hotel Frontenac were situated on the opposite side of Lake Betsie from its Elberta car ferry terminal. While cross-lake car ferry traffic was one of the line's significant sources of revenue, the railroad also sought to exploit the tourist appeal of Frankfort and Lake Michigan. Unfortunately, the Hotel Frontenac, built in 1907, was destroyed in a January 12, 1912, fire. (James Harlow collection.)

46

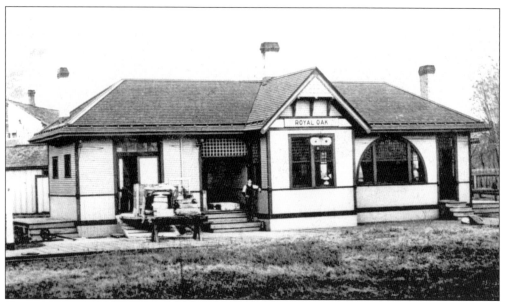

GRAND TRUNK DEPOT, ROYAL OAK. As originally built, the tracks of the Detroit & Pontiac Railroad (a Grand Trunk Railway predecessor) were located directly east of Woodward Avenue. In the 1920s, when the state decided to widen Woodward between Royal Oak and West Bloomfield, the Grand Trunk was forced to move its main line approximately one mile east. Pictured above is the Royal Oak station that existed on the original alignment. (James Harlow collection.)

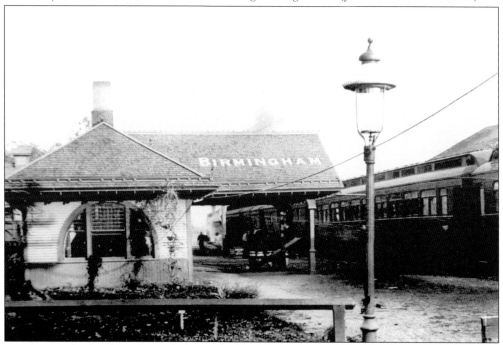

GRAND TRUNK DEPOT, BIRMINGHAM. The State of Michigan's 8.1-mile Woodward Avenue–widening project also forced the Grand Trunk to build a new depot at Birmingham. The original wood frame station, with its half-moon window and covered walkway to the passenger boarding platform, is shown above. (James Harlow collection.)

47

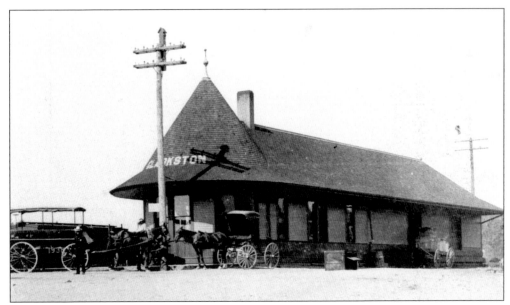

GRAND TRUNK DEPOT, CLARKSTON. The first station at Clarkston was a two-story gable-roofed structure built by the Detroit & Milwaukee Railway. It fell victim to a fire in the 1890s, and the Grand Trunk Railway replaced it with this unique "witch's hat"–style depot. It is interesting to note that a similar fate befell the second Clarkston depot in 1923. At that time, the railroad built a third station to serve the community. (James Harlow collection.)

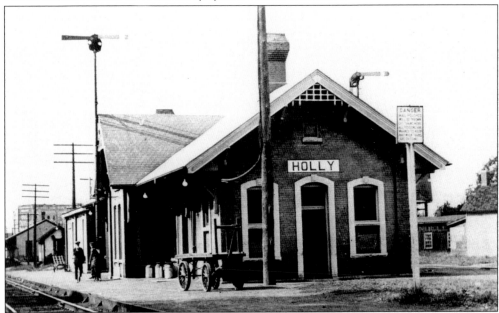

UNION DEPOT, HOLLY. Trains of the Grand Trunk and the Pere Marquette Railway both used this 1890 brick station at Holly. Grand Trunk predecessor Detroit & Milwaukee was the first railroad to arrive here in July 1856, followed by the Flint & Holly Rail Road (the Pere Marquette's predecessor) in November 1864. The Holly, Wayne & Monroe Railway (another Pere Marquette predecessor) did not complete its line from Holly to Northville until November 1871. (James Harlow collection.)

48

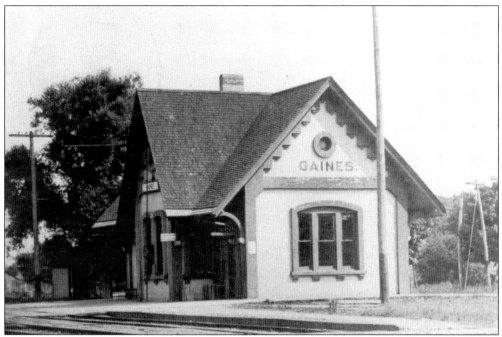

GRAND TRUNK DEPOT, GAINES. In June 1920, there were only two trains running between Detroit and the car ferry docks at Grand Haven, neither of which stopped at Gaines. On weekdays, however, the community was served by four trains—two departing for Grand Rapids and two for Detroit. Connections were also available at Durand with the other Grand Trunk lines as well as trains on the Ann Arbor Railroad. (James Harlow collection.)

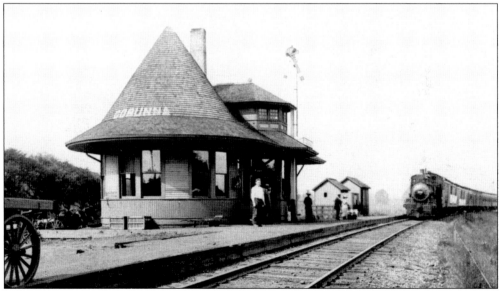

GRAND TRUNK DEPOT, CORUNNA. Corunna was located 75.5 miles west of Detroit and 9 miles west of the big railroad junction at Durand. The Grand Trunk served the community of 1,800 people from this "witch's hat" depot. In the summer of 1920, two other railroads called on Corunna—the Ann Arbor and the Michigan Railway. The Michigan Railway provided electric interurban service from Lansing to Owosso and Corunna. (James Harlow collection.)

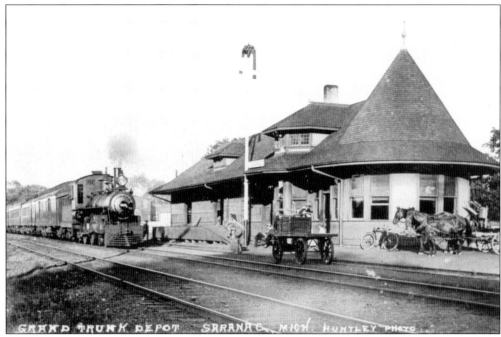

GRAND TRUNK DEPOT, SARANAC. Hoping to attract more eastern settlers, Saranac was named after a resort town of the same name in New York State. Located 132.5 miles west of Detroit, it was the fourth "witch's hat"–style depot on the line to Grand Haven. The Detroit & Milwaukee Railway completed its line through Saranac in July 1858. (James Harlow collection.)

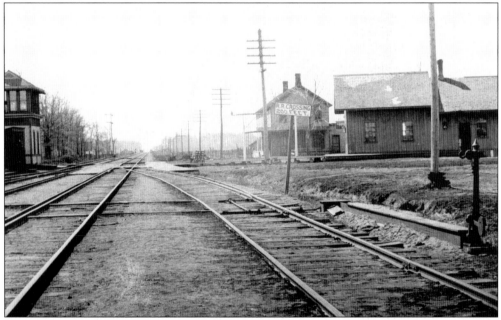

PERE MARQUETTE DEPOT, WAYNE. According to its timetable, dated November 30, 1919, the Pere Marquette Railway was serving Wayne with four passenger trains each business day. With closely scheduled connections available at Plymouth, convenient travel from Wayne to Grand Rapids, Saginaw, and Bay City was possible. (James Harlow collection.)

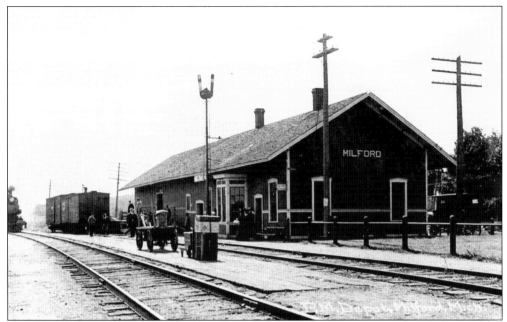

PERE MARQUETTE DEPOT, MILFORD. In addition to the Toledo trains, those originating in Detroit joined the Ludington line at Plymouth, effectively doubling the frequency of train service through Milford. With eight departures each business day, through trains could be boarded for Toledo, Detroit, Flint, Saginaw, Bay City, Ludington, and Manistee. (James Harlow collection.)

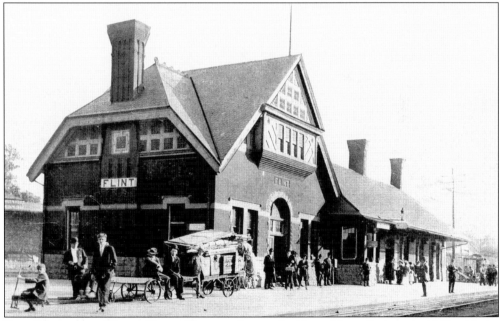

PERE MARQUETTE DEPOT, FLINT. Flint was first reached by rail from Saginaw in 1863, with the line south to Holly being completed the following year. A complete rail line south to Toledo was not completed until 1872. With a 1920 population of 38,550, Flint was a major source of revenue for the Pere Marquette, and was served by this substantial brick-and-limestone depot. (James Harlow collection.)

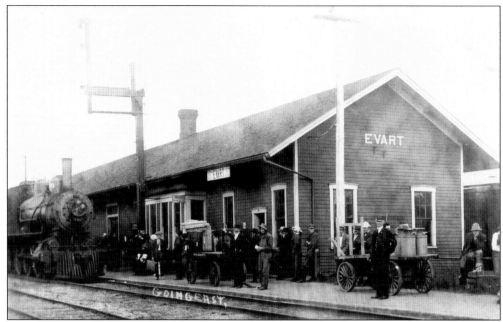

PERE MARQUETTE DEPOT, EVART. Evart was located 60.7 miles east of Ludington. In June 1920, the community was served by four trains each business day, although the depot was intensely busy but twice a day. At 9:40 a.m., the overnight Detroit-to-Ludington train met its daylight counterpart headed for Detroit. Similarly at 3:00 p.m., train No. 3 from Detroit met train No. 6 from Ludington. (James Harlow collection.)

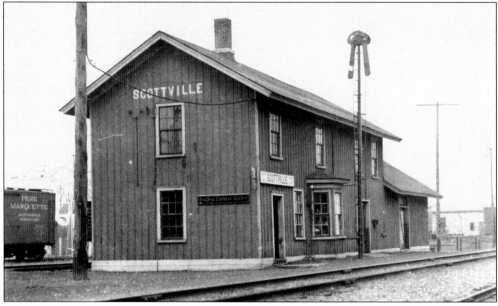

PERE MARQUETTE DEPOT, SCOTTVILLE. The Flint & Pere Marquette Railway (a Pere Marquette Railway predecessor) completed the final 48 miles of its line to Ludington via Mason Center in December 1874. Scottville was previously known as Mason Center due to its central location in Mason County. Its name was changed to Sweetland for a time, before sawmill owner Hiram Scott gave the village its present name in 1882. (James Harlow collection.)

Three

TO THE NORTHERN RESORTS

Michigan's Lower Peninsula resort areas attracted summer vacationers not only from Detroit and Chicago but from other large cities in Ohio and Indiana as well. The Detroit & Mackinac Railway, which served neither of its namesake cities, catered to travelers making their way to summer resorts on Michigan's "other" coast. Tawas Beach was a 200-acre park created by the railway on Lake Huron to encourage day-trip excursions and extended summer stays. The park featured a three-quarter-mile-long beach, a boat dock, a baseball diamond, a dance pavilion, wooded hiking trails, and 10 summer cottages. A special train known as the *Tawas Beach Flyer* transported Bay City passengers the 63 miles to the park in 2 hours and 13 minutes. In addition to its facilities at Tawas Beach, the Detroit & Mackinac had attractive depots at Harrisville and Aloha.

Known as the *Fishing Line*, the Grand Rapids & Indiana Railroad served some of the most well-known resorts on the west side of the state. While many of its depots were modest in size and conservative in appearance, the trains serving them catered to some of America's wealthiest summer tourists. Petoskey and Bay View were two popular destinations, catering to upscale vacationers with deluxe accommodations and offering a variety of interesting day-trip possibilities. For fishermen, the stations at Brutus and Pellston provided easy access to the Maple River, one of the finest trout streams in Michigan. Burt Lake, Carp Lake, and Douglas Lake also provided excellent fishing opportunities.

Detroit, Saginaw, and Bay City were the Michigan Central Railroad's primary customer markets for summer travelers destined for Mackinaw City, Mackinac Island, and points in Michigan's Upper Peninsula. The Michigan Central also served a number of resort areas en route to Mackinaw City, among them Grayling, Otsego Lake, Gaylord, and Mullet Lake. While many of the depots along its line were built from standard company designs, some truly exquisite structures existed at Columbiaville, Bay City, and Standish.

With train service available from Detroit, Grand Rapids, and Chicago, the Pere Marquette Railway was also a major player serving the northern Michigan resorts. Its rambling wood frame station at Petoskey, located on the shores of Little Traverse Bay, and its turreted wood frame depot at Charlevoix, situated on its namesake lake, were both beautiful places to begin a northern Michigan summer adventure.

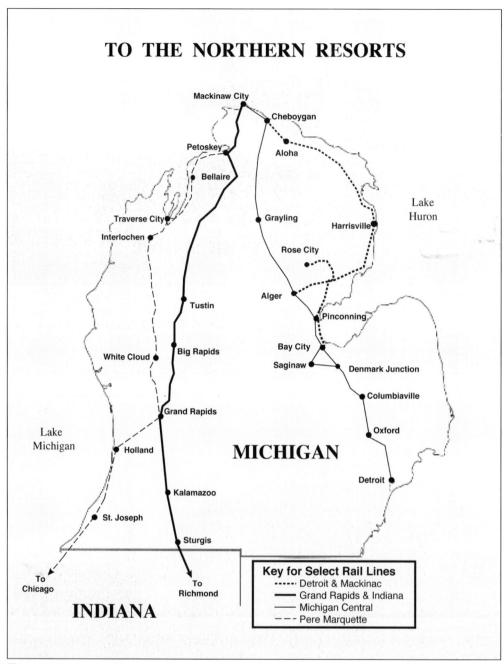

TO THE NORTHERN RESORTS

Key for Select Rail Lines
- ····· Detroit & Mackinac
- ▬▬ Grand Rapids & Indiana
- ─── Michigan Central
- ─ ─ Pere Marquette

TO THE NORTHERN RESORTS. Transporting wealthy tourists to the northern Michigan summer resorts was a lucrative business for the railroads in the second decade of the 20th century.

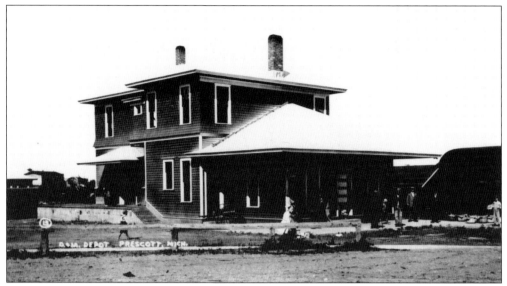

DETROIT & MACKINAC DEPOT, PRESCOTT. The original main line of the Detroit, Bay City & Alpena Railroad (a Detroit & Mackinac Railway predecessor) ran by way of Prescott and National City to a connection with the Michigan Central Railroad at Alger. Seeking a route of its own into Bay City, the Detroit & Mackinac opened a shorter route from Foss (in Bay City) to National City via Omer in September 1896. The original main line between Prescott and Alger was abandoned that same year, leaving Prescott at the end of a branch line. (James Harlow collection.)

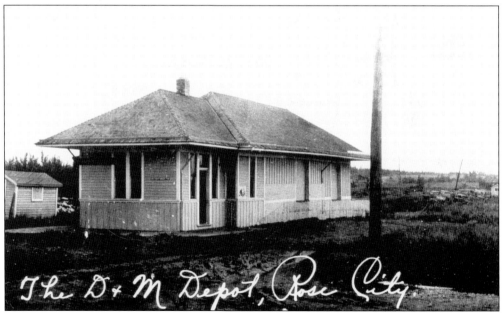

DETROIT & MACKINAC DEPOT, ROSE CITY. In 1892, the owners of the French & Rose Lumber Company persuaded the Detroit, Bay City & Alpena (a Detroit & Mackinac predecessor) to build a 31.8-mile branch line from National City to Rose City to handle lumber shipments. According to their June 1920 timetable, train No. 21 and No. 22 provided daily-except-Sunday service to Rose City, with excellent main line connections. (James Harlow collection.)

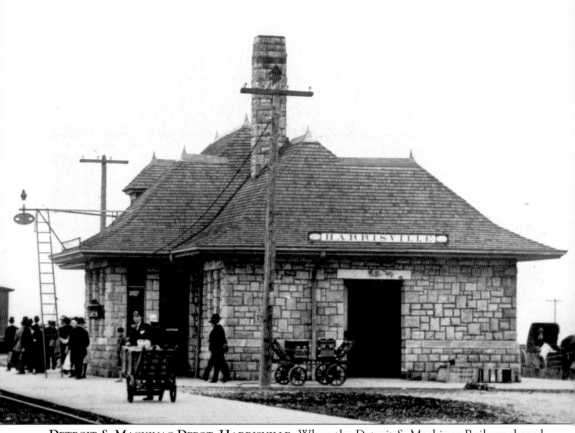

DETROIT & MACKINAC DEPOT, HARRISVILLE. When the Detroit & Mackinac Railway shared its plans for a new station at Harrisville with community leaders, George Colwell, a prominent resident, asked if the station could be built of stone. The railway replied that a stone depot would be too costly. But Colwell persisted, "What if the community supplied the stone at no cost to the company?" The railway finally agreed, and even though the stone provided was not nearly enough to finish the job, the Detroit & Mackinac completed what was arguably the most elegant station along its line. In the railroad's timetable dated June 27, 1920, Harrisville was a regularly scheduled stop for all four trains operating between Bay City and Cheboygan. Convenient Bay City connections were available with Pere Marquette Railway trains for those travelers continuing on to Saginaw or Detroit. (James Harlow collection.)

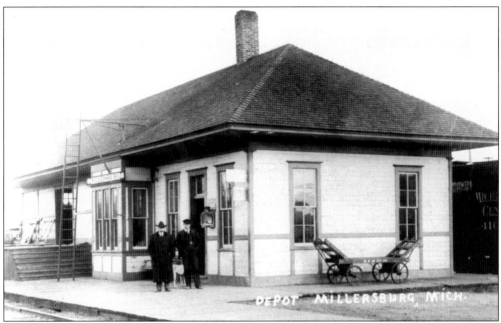

DETROIT & MACKINAC DEPOT, MILLERSBURG. The Detroit & Mackinac's Northern Division extended 73 miles from Alpena to Cheboygan. Its main line through the community of Millersburg was completed in September 1898, and a sawmill was built here the following year. Millersburg was formally incorporated as a village in 1901, and 15 years later, the wood frame station shown above was replaced by a cement-block structure. (Dave Tinder collection.)

DETROIT & MACKINAC DEPOT, ONAWAY. With a 1920 population of 2,600 residents, Onaway was one of the larger communities along the Lake Huron shore between Alpena and Cheboygan. The community had several names during its early history. It was first called Shaw in 1882, followed by Onaway in 1886, Adalaska in 1893, and back to Onaway in 1897. (Dave Tinder collection.)

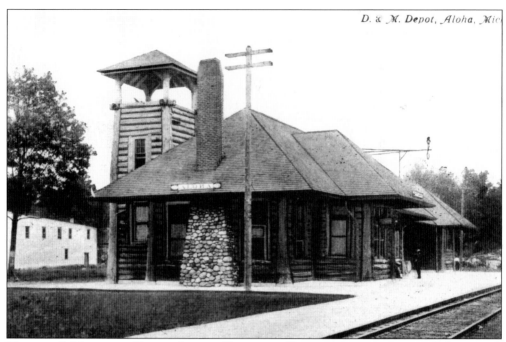

DETROIT & MACKINAC DEPOT, ALOHA, TRACKSIDE VIEW. Aloha grew up around the sawmill operation of James Patterson and the F. Hout general store near the shores of Mullet Lake. Patterson had made a trip to Hawaii and named the community after the Hawaiian word commonly used for greetings and farewells. The Detroit & Mackinac Railway completed its line through Aloha in May 1904. (James Harlow collection.)

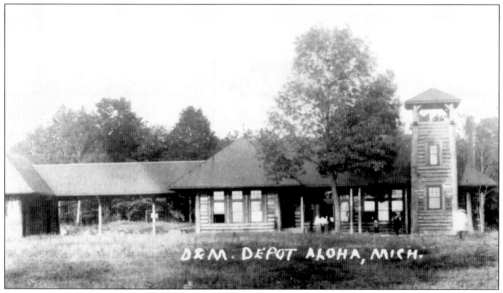

DETROIT & MACKINAC DEPOT, ALOHA, STREET-SIDE VIEW. The log cabin–style depot at Aloha was perhaps the most unique station on the railroad. In addition to its all-log construction, the depot featured a fieldstone waiting room fireplace and an open lookout tower. With the village situated on the east shore of Mullet Lake, viewing sunsets over the lake from the depot's tower must have been inspiring. (Dave Tinder collection.)

58

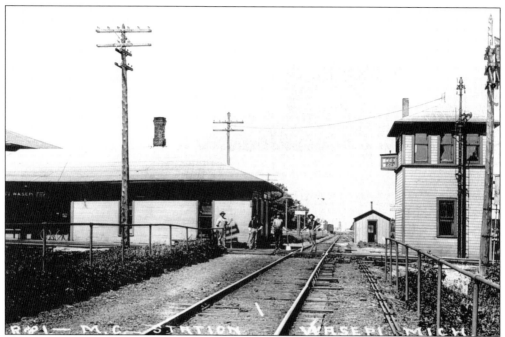

UNION DEPOT, WASEPI. Wasepi was located 13.1 miles north of the Michigan/Indiana state line on the Grand Rapids & Indiana Railroad's Richmond, Indiana, to Mackinaw City line. The Michigan Central Railroad's Jackson-to-Niles line crossed the north/south Grand Rapids & Indiana at this point. The two railroads shared the L-shaped, wood frame station at the left. (James Harlow collection.)

GRAND RAPIDS & INDIANA DEPOT, KALAMAZOO. The Grand Rapids & Indiana completed its line to Kalamazoo in the summer of 1870. Its first depot here was destroyed by fire. In 1874, the railroad built this replacement station designed by the architectural firm of Bush & Patterson. The station featured wide porches, a shallow hip roof, and three decorative chimneys. (James Harlow collection.)

GRAND RAPIDS & INDIANA DEPOT, ROCKFORD. In 1920, this small community 13.8 miles north of Grand Rapids was served well by the Grand Rapids & Indiana Railroad. Northbound residents had the choice of an overnight or daylight train to Mackinaw City, as well as daylight service to Cadillac. Similarly, there were three southbound departures for Grand Rapids and points beyond. (James Harlow collection.)

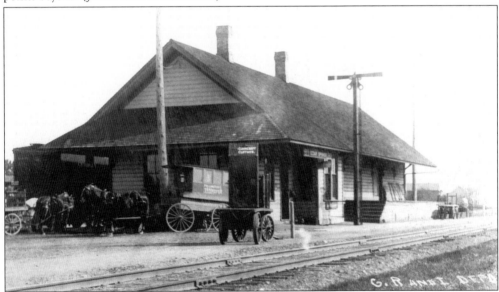

GRAND RAPIDS & INDIANA DEPOT, CEDAR SPRINGS. In addition to being served by the Grand Rapids & Indiana, Cedar Springs was also a station on the Grand Trunk Railway's Owosso-to-Muskegon line. While each company maintained separate station facilities, the Grand Rapids & Indiana was clearly the dominant railroad in town, both in terms of train service offerings and station facilities. (James Harlow collection.)

60

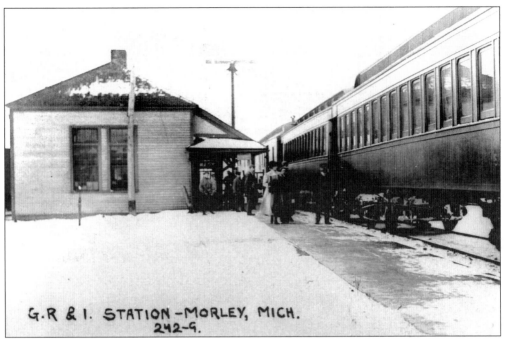

G.R & I. STATION—MORLEY, MICH.
242-9.

GRAND RAPIDS & INDIANA DEPOT, MORLEY. The Grand Rapids & Indiana completed its line as far as Morley (40.4 miles north of Grand Rapids) in June 1869. Buoyed by the railroad's coming, incorporation papers for the village were filed the following year. Morley residents were served by this simple wood frame station in 1920, a design duplicated at several other small towns along the line. (James Harlow collection.)

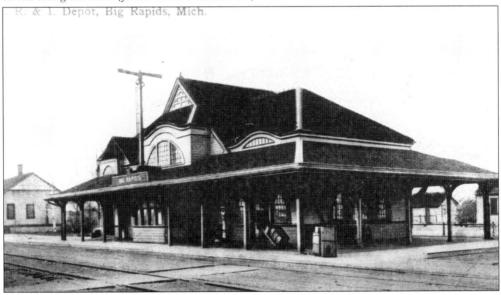

GRAND RAPIDS & INDIANA DEPOT, BIG RAPIDS. Known originally as Leonard, the name of the community was changed to Big Rapids in September 1859, due to its location adjacent to the largest rapid on the Muskegon River. With a 1920 population of 6,500, Big Rapids was served by this attractive station. The Pere Marquette Railway also served the city with a branch line from Ionia and another from Muskegon. (James Harlow collection.)

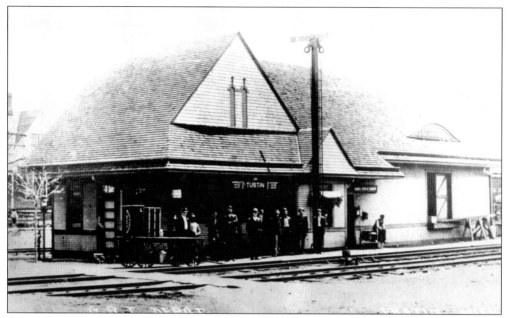

GRAND RAPIDS & INDIANA DEPOT, TUSTIN. In the summer of 1920, Tustin's 450 residents were served out of this uniquely styled wood frame depot. Northbound service out of Tustin was somewhat limited, with a 10:24 a.m. train to Mackinaw City and a 9:22 p.m. train to Cadillac. Southbound there were three departure choices for travel to Grand Rapids—7:24 a.m., 1:15 p.m., and 5:20 p.m. (James Harlow collection.)

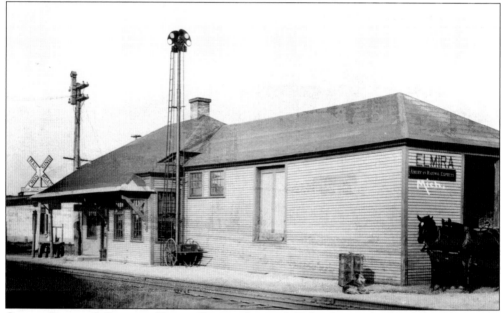

GRAND RAPIDS & INDIANA DEPOT, ELMIRA. Located 68.3 miles north of Cadillac, Elmira was a small community of 500 residents in 1920, where the Boyne City, Gaylord & Alpena Railroad crossed the Grand Rapids & Indiana Railroad. The junction was located 1.4 miles north of town. The wood frame Elmira depot was a design similar to that used for the station at Morley, 126 miles to the south. (James Harlow collection.)

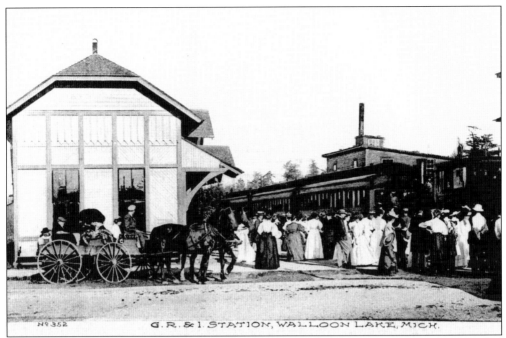

No 352 G.R. & I. STATION, WALLOON LAKE, MICH.

GRAND RAPIDS & INDIANA DEPOT, WALLOON LAKE. Service to Walloon Lake consisted of three daily round-trips from Petoskey. The trip took 30 minutes, with a regularly scheduled stop at Clarion, where the trains left the main line and got on the Walloon Lake Branch. At Walloon Lake, vacationers could board a steamboat, which stopped at more than a dozen resorts around the lake. (James Harlow collection.)

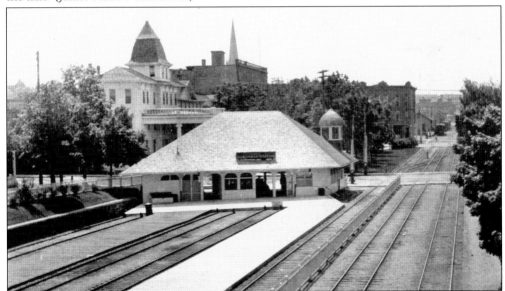

GRAND RAPIDS & INDIANA DEPOT, LAKE STREET, PETOSKEY. The Grand Rapids & Indiana built this attractive station at Lake Street in Petoskey to accommodate its summer suburban service customers. The trains allowed wealthy tourists to dine, shop, and explore the neighboring resort areas around Little Traverse Bay, Walloon Lake, and Crooked Lake. (James Harlow collection.)

63

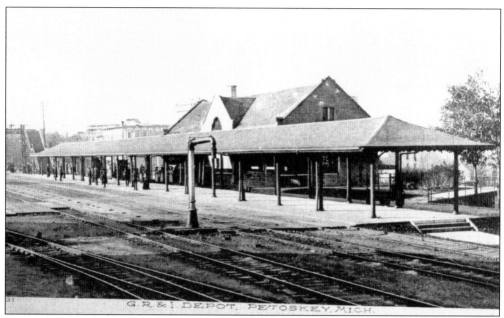

GRAND RAPIDS & INDIANA DEPOT, BAY STREET, PETOSKEY. Bay Street was the main Grand Rapids & Indiana Railroad station in Petoskey. In June 1920, the station handled eight main line trains between Grand Rapids and Mackinaw City. Catering to the wealthy, the nearby Cushman Hotel referred to itself as the "home of the better class," and its advertising boasted that it offered hot and cold running artesian mineral water in every room. (James Harlow collection.)

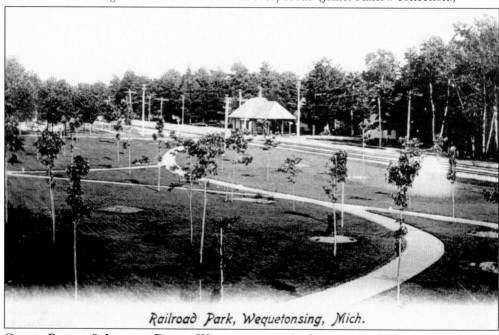

GRAND RAPIDS & INDIANA DEPOT, WEQUETONSING. In the summer of 1919, the most popular suburban service destination was Harbor Springs with seven daily round-trips. The service began each morning in Petoskey at 6:50 a.m. and ended at 10:45 p.m. The station at Wequetonsing was one of the regular stops and was situated in a parklike setting. (James Harlow collection.)

64

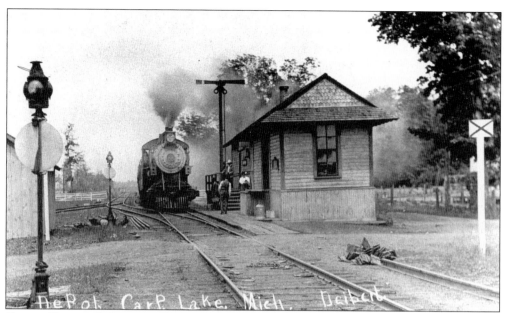

GRAND RAPIDS & INDIANA DEPOT, CARP LAKE. Between 1876 and 1881, the Grand Rapids & Indiana added no new mileage to its rail system. Finally in July 1882, the Grand Rapids, Indiana & Mackinaw Railroad (controlled by the Grand Rapids & Indiana) completed its line between Kegomic (north of Bay View) and Mackinaw City. Carp Lake was located seven miles south of Mackinaw City. (James Harlow collection.)

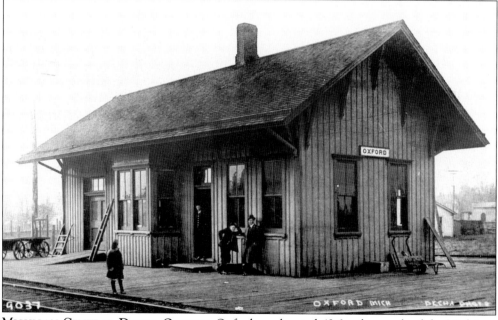

MICHIGAN CENTRAL DEPOT, OXFORD. Oxford was located 43.6 miles north of the Michigan Central Railroad's Third Street Station in Detroit. During 1872 and 1873, the Detroit & Bay City Railway (a Michigan Central predecessor) completed its rail line between Bay City Junction in Detroit and the east-side station in Bay City. The line was opened as far as Oxford in October 1872. (James Harlow collection.)

65

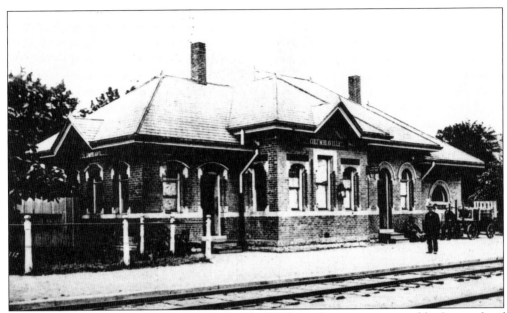

MICHIGAN CENTRAL DEPOT, COLUMBIAVILLE. William Peter was responsible for much of Columbiaville's growth at the end of the 19th century, and he generously replaced the depot here with this ornate brick structure. However, there was a deed restriction that specified that all trains must stop here. According to Detroit Division employee timetable No. 396, dated June 26, 1921, all trains were making regularly scheduled or flag stops at Columbiaville. (James Harlow collection.)

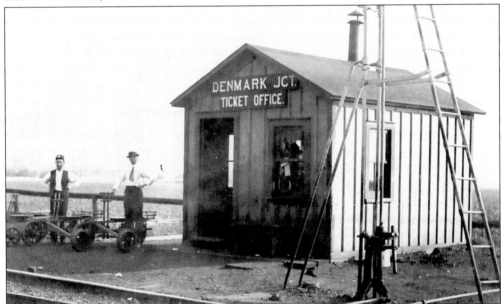

MICHIGAN CENTRAL DEPOT, DENMARK JUNCTION. Initially, the Detroit & Bay City Railway (a Michigan Central Railroad predecessor) ran its trains to Bay City by way of Reese. That changed in 1879, when the company opened a new line into Bay City by way of Saginaw. In June 1920, most of the Detroit-to-Bay City trains were switched off the original line at Denmark Junction and run north via Saginaw. (Dave Tinder collection.)

66

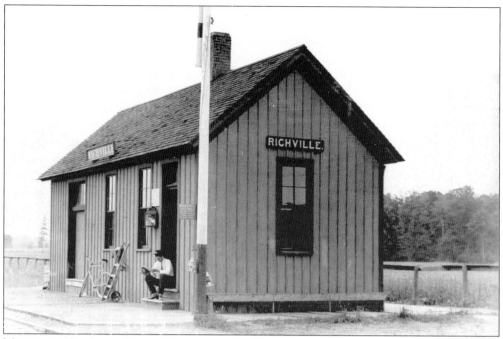

MICHIGAN CENTRAL DEPOT, RICHVILLE. Rather than continuing to run its trains directly from Detroit to Bay City as it had done since 1873, the Detroit & Bay City (a Michigan Central predecessor) elected to modify its route to include Saginaw. In 1879, it completed a 15.9-mile connector from Denmark Junction to Saginaw. Richville was on that new line and was the first station west of Denmark Junction. (James Harlow collection.)

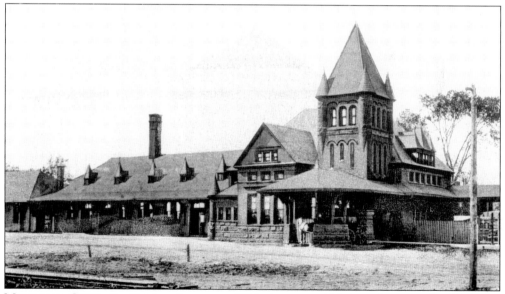

MICHIGAN CENTRAL DEPOT, SAGINAW. With its pyramidal-shaped tower, the Michigan Central's redbrick and sandstone station on Genesee Avenue in Saginaw was an impressive structure. According to its timetable dated June 27, 1920, the depot served 10 Detroit–Bay City line trains (five northbound and five southbound) and eight Jackson–Saginaw line trains (four northbound and four southbound) each business day. (James Harlow collection.)

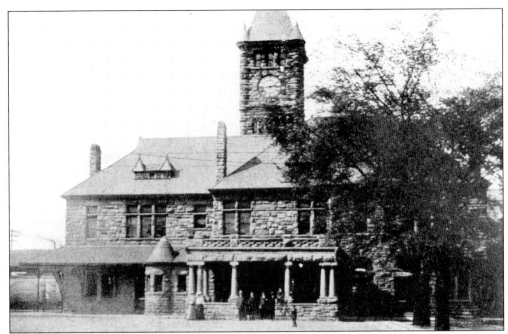

MICHIGAN CENTRAL DEPOT, BAY CITY EAST SIDE. The Michigan Central Railroad built a beautiful cut-stone station on the east side of Bay City. Also housed within the depot were the railroad's Northern Division dispatching offices. In June 1922, employee timetable No. 398 showed scheduled passenger service between Bay City and Mackinaw City, Bay City and Jackson, and on the Gladwin, Midland, Bagley, Twin Lake, and East Jordan Branches. (James Harlow collection.)

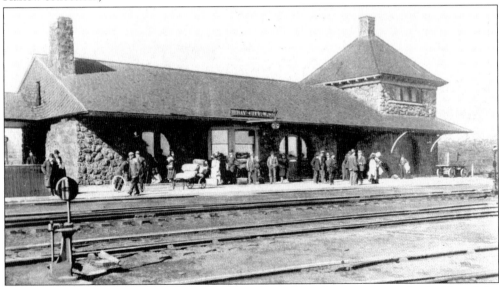

MICHIGAN CENTRAL DEPOT, BAY CITY WEST SIDE. Bay City grew up on both sides of the Saginaw River, resulting in an east-side community and a west-side community. Not wanting to play favorites, the Michigan Central built stations on both sides of the river. While not as elaborate as its east-side station, the cut-stone west-side depot was nonetheless an attractive structure. (James Harlow collection.)

68

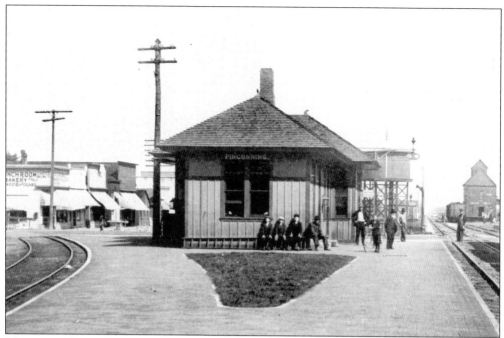

MICHIGAN CENTRAL DEPOT, PINCONNING. Pinconning was located 18.9 miles north of Bay City's east-side station and took its name from a Native American word meaning "potato place." The wood frame station here served not only the Bay City-to-Mackinaw City trains but also those on the Gladwin Branch, which swung off to the left in the postcard view above. (James Harlow collection.)

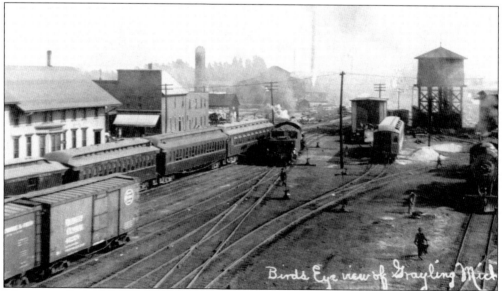

MICHIGAN CENTRAL DEPOT, GRAYLING. Grayling was the halfway point between Bay City and Mackinaw City and was an important Northern Division terminal. During the postcard era, the railroad facilities at Grayling included a two-story wood frame station, a freight house, a water tank, a 16-stall roundhouse, and a small freight yard. The depot's second floor contained two kitchens and rooms for train crews laying over between runs. (James Harlow collection.)

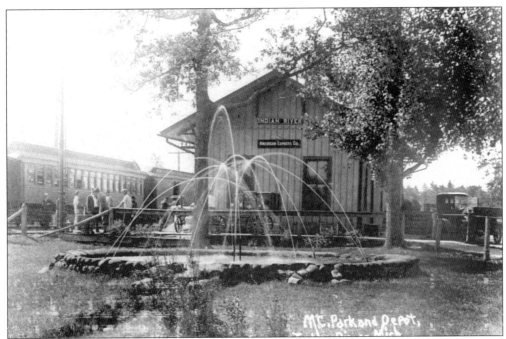

MICHIGAN CENTRAL DEPOT, INDIAN RIVER. Built in 1892, the wood frame combination station at Indian River was a standard Michigan Central Railroad design that the company used in many communities along its lines. The fieldstone fountain was a nice touch for passengers and residents alike, and gave the depot grounds an appealing character. (James Harlow collection.)

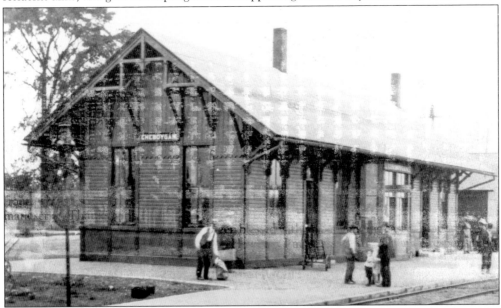

MICHIGAN CENTRAL DEPOT, CHEBOYGAN. Cheboygan was located 16.1 miles from the Michigan Central's northern terminus at Mackinaw City. It was also served by the Detroit & Mackinac Railway, but the Michigan Central was the dominant carrier in town, with 10 arrivals and departures each business day, which included overnight service to and from Detroit. The Detroit & Mackinac only offered four daylight runs. (James Harlow collection.)

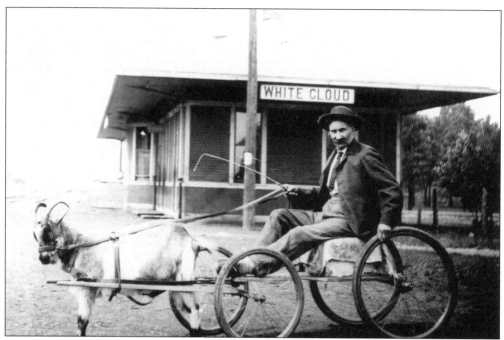

PERE MARQUETTE DEPOT, WHITE CLOUD. White Cloud was located 47.3 miles north of Grand Rapids on the company's line to Petoskey. In 1920, this community of 1,000 was a regularly scheduled stop for six trains each business day on the Grand Rapids–Petoskey line. In addition, the wood frame depot also served the trains on the Pere Marquette Railway's Muskegon–Big Rapids branch line. (James Harlow collection.)

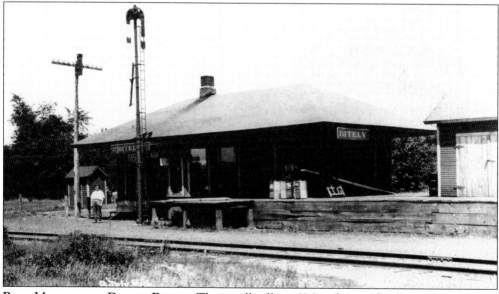

PERE MARQUETTE DEPOT, BITELY. This small village 63.3 miles north of Grand Rapids was named after Steven and Jerome Bitely, who founded a community here in 1889, nearly six years after the coming of the railroad in December 1883. Brother Steven built and operated a sawmill here as well. While the station sign read Bitely, the post office referred to the community as Biteley. (James Harlow collection.)

71

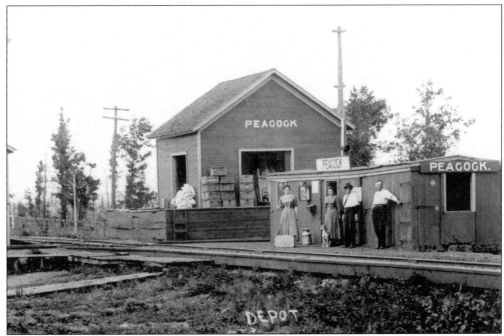

UNION DEPOT, PEACOCK. Peacock was a small community clustered around the crossing of the Pere Marquette Railway's Grand Rapids–Petoskey line and the Michigan East & West Railway's Manistee–Marion line. Although the depot accommodations here were rather spartan, a fair number of trains served the junction in 1916—six on the Pere Marquette and four on the Michigan East & West. (James Harlow collection.)

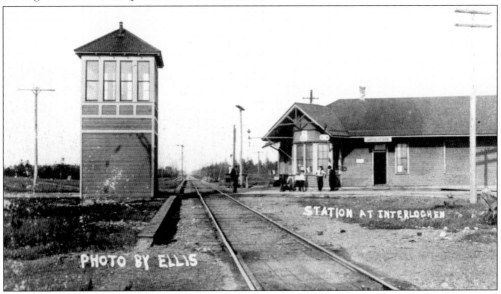

UNION DEPOT, INTERLOCHEN. The Pere Marquette and the Manistee & Northeastern Rail Road shared station facilities at Interlochen. Both railroads arrived here in 1890, and the interlocking tower at the left protected the crossing. Traverse City was 13 miles to the northeast on the Pere Marquette and 25 miles distant on the Manistee & Northeastern, which took the long way there by way of Lake Ann and Solon. (James Harlow collection.)

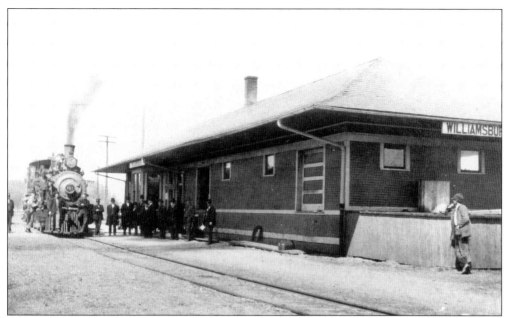

PERE MARQUETTE DEPOT, WILLIAMSBURG. Once Traverse City was reached in 1890, no additional trackage north of that point was completed until 1892. In January 1892, the Chicago & North Michigan Railroad (owned by the Chicago & West Michigan Railway and a Pere Marquette predecessor) completed 11.5 miles of line to Williamsburg. Originally situated along Mill Creek, the community moved a quarter mile to the south with the coming of the railroad. (James Harlow collection.)

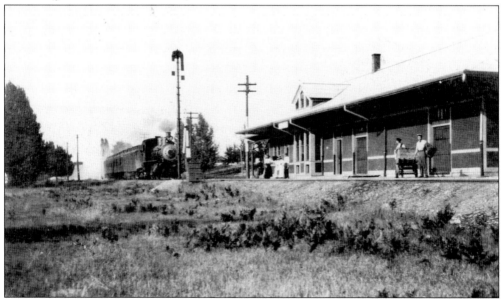

PERE MARQUETTE DEPOT, ALDEN. Originally known as Spencer Creek, this community was given a new name in July 1892, honoring William Alden Smith, the Chicago & West Michigan's general attorney in Grand Rapids. Alden was a regularly scheduled stop for all six trains shown in the railroad's timetable dated June 6, 1920, including the two overnight trains running between Bay View (a mile north of Petoskey) and Chicago. (James Harlow collection.)

73

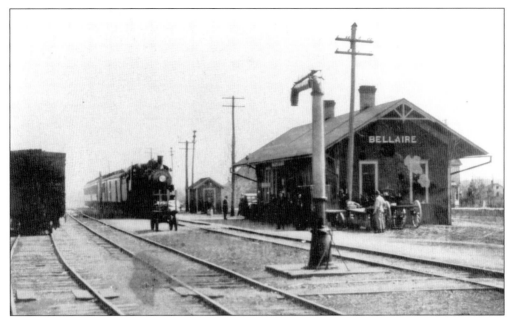

UNION DEPOT, BELLAIRE. The station facilities at Bellaire were shared with the East Jordan & Southern Railroad. In the summer of 1920, all four of the East Jordan & Southern trains operating between East Jordan and Bellaire made a close connection with one of the Pere Marquette Railway's Grand Rapids–Petoskey line trains. Changing trains at Bellaire was a simple matter of stepping off one train and getting on another. (James Harlow collection.)

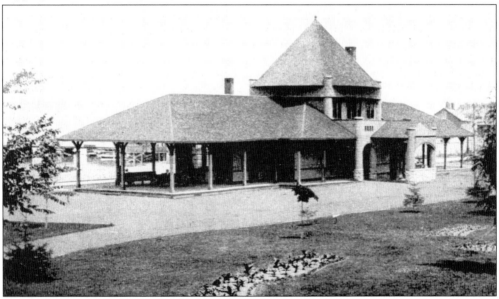

PERE MARQUETTE DEPOT, PETOSKEY. In June 1893, the year following the completion of its line into Petoskey, the Chicago & West Michigan Railway and the Detroit, Lansing & Northern Railroad (both Pere Marquette predecessors) took out a full-page advertisement in the *Official Guide of the Railways*, billing themselves as "the Scenic Line to Michigan Summer Resorts." The beautiful Petoskey station, situated on the shores of Little Traverse Bay, reinforced that notion. (James Harlow collection.)

74

Four

Transforming the Upper Peninsula Wilderness

With the required number of inhabitants, the territorial government of Michigan was ready to make the transformation from territory to statehood in 1833. However, Congress postponed Michigan's admission to the union until a land dispute with Ohio over Maumee Bay was resolved. The dispute was finally settled by Congress in 1836, when it awarded the 470-square-mile parcel of land known as the "Toledo Strip" to Ohio. To compensate, Michigan was given a large tract of land west of its existing Upper Peninsula territorial boundaries. The Upper Peninsula would now take in all lands from Sault Ste. Marie west to the Montreal and Menominee Rivers.

Michigan was granted statehood in 1837, but not all were happy with the land deal. Many felt that the additional Upper Peninsula land was nothing more than a barren wilderness and a region of perpetual snow. Less than a decade later, however, rich copper deposits were discovered in the Keweenaw Peninsula as well as iron ore near Negaunee. In addition, the "new" land was covered with abundant stands of timber. The railroads were the enablers that allowed mining and lumbering enterprises to expand their operations, and begin the process of transforming the Upper Peninsula from a wilderness to an area that was economically viable.

Land grants played a major role in encouraging railroad construction. The largest grant of 1.3 million acres was awarded to the Detroit, Mackinac & Marquette Railroad (a Duluth, South Shore & Atlantic Railway predecessor) in 1881 for completing its line between Marquette and St. Ignace. This particular line was considered extremely important since it would unite the two peninsulas by way of a jointly owned railroad car ferry operation between St. Ignace and Mackinaw City. The Mackinac Transportation Company was jointly owned by the Detroit, Mackinac & Marquette, the Grand Rapids & Indiana Railroad, and the Michigan Central Railroad.

Railroad station architecture varied considerably by individual railroad across Michigan's Upper Peninsula, although wood was the common building material utilized for most of them. Many railroads used standardized depot plans, and as a result, their stations shared a family resemblance to one another. Arguably, the Chicago, Milwaukee & St. Paul Railway had the most attractive depots in the Upper Peninsula. The St. Paul Road stations at Crystal Falls and Menominee are two beautiful examples worthy of mention. Although, the Chicago & North Western Railway depot at Ironwood, the two-story Duluth, South Shore & Atlantic station at Humboldt, and the station at Trout Lake, shared by the Duluth, South Shore & Atlantic and Minneapolis, St. Paul & Sault Ste. Marie Railway (Soo Line), were all very handsome structures.

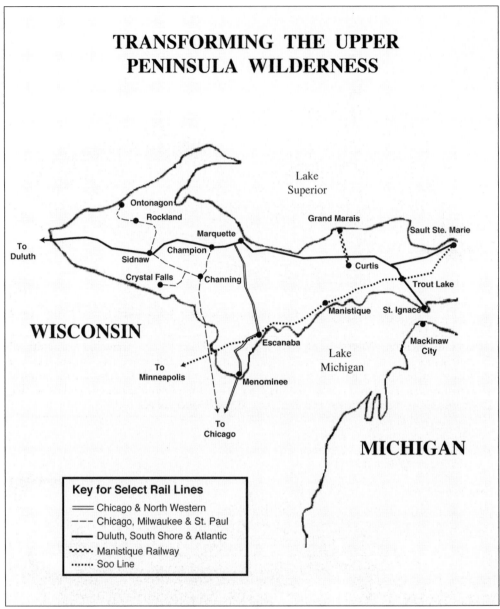

TRANSFORMING THE UPPER PENINSULA WILDERNESS

Lake Superior

Ontonagon
Rockland
Grand Marais
Sault Ste. Marie
Marquette
To Duluth
Champion
Sidnaw
Curtis
Crystal Falls
Channing
Trout Lake
Manistique
St. Ignace
WISCONSIN
Escanaba
Lake Michigan
Mackinaw City
To Minneapolis
Menominee
To Chicago
MICHIGAN

Key for Select Rail Lines
Chicago & North Western
Chicago, Milwaukee & St. Paul
Duluth, South Shore & Atlantic
Manistique Railway
Soo Line

TRANSFORMING THE UPPER PENINSULA WILDERNESS. The railroads were the enablers that allowed mining and lumbering interests to develop the Upper Peninsula's rich natural resources fully.

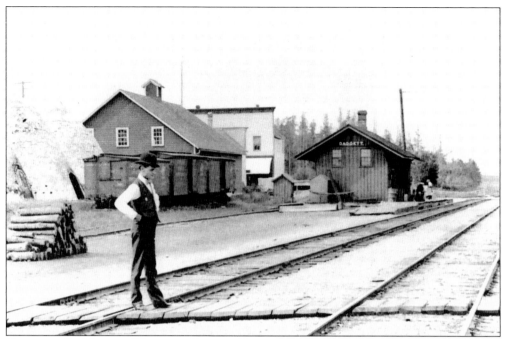

CHICAGO & NORTH WESTERN DEPOT, DAGGETT. Daggett was a small community of 400 residents in 1920 and was located 25 miles north of Menominee on the railroad's Green Bay, Wisconsin, to Ishpeming line. In June 1920, six trains stopped at Daggett each business day—a pair between Chicago and Ishpeming, another pair between Menominee and Escanaba, and a third pair between Chicago and Escanaba. (Dave Tinder collection.)

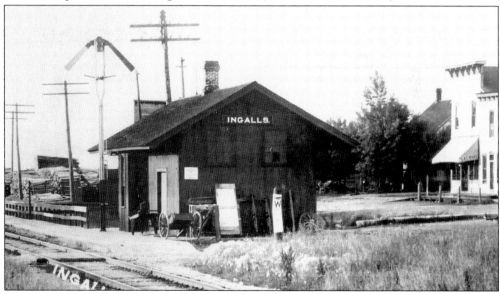

CHICAGO & NORTH WESTERN DEPOT, INGALLS. In 1872, the Chicago & North Western Railway completed its rail line between Menominee and Escanaba. The small wood frame depot at Ingalls was a standard design, which the railroad duplicated several times along the line. This community was named after Judge Eleazer Ingalls, who was instrumental in organizing Menominee County. (Dave Tinder collection.)

77

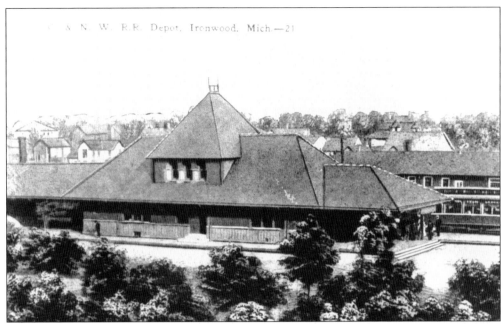

CHICAGO & NORTH WESTERN DEPOT, IRONWOOD. In 1892, the Milwaukee, Lake Shore & Western Railway (a Chicago & North Western Railway predecessor) replaced its wood frame station in Ironwood with this attractive redbrick and sandstone structure. The depot was capped with a multilevel hip roof and cross dormer, and was covered in slate. With a 1920 population of 13,000, Ironwood was the largest city on the Gogebic Iron Range. (James Harlow collection.)

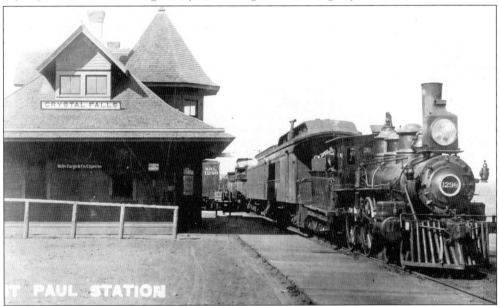

CHICAGO, MILWAUKEE & ST. PAUL DEPOT, CRYSTAL FALLS. Crystal Falls took its name from a nearby waterfall on the Paint River. The community was located on the St. Paul Road's branch line from Kelso Junction to Iron River. With its bell-cast hip roof and octagonal-shaped tower above the bay window, the Crystal Falls station was perhaps the most attractive of the railroad's standard depot designs. (Dave Tinder collection.)

78

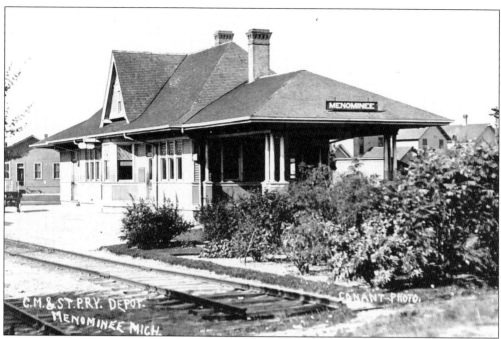

CHICAGO, MILWAUKEE & ST. PAUL DEPOT, MENOMINEE. One would never suspect that the St. Paul Road's Menominee station was located at the end of a 22.3-mile branch line from Crivitz, Wisconsin. Despite its branch line disadvantage, the St. Paul Road's Chicago-to-Menominee overnight train was fully competitive with the main line service offered by the Chicago & North Western—9 hours and 20 minutes versus 9 hours flat. (Dave Tinder collection.)

CHICAGO, MILWAUKEE & ST. PAUL DEPOT, ROCKLAND. The Ontonagon & Brule River Railroad (a Chicago, Milwaukee & St. Paul Railway predecessor) completed its rail line between Mass and Ontonagon via Rockland in August 1882. More than 10 years would pass before the railroad was completed between Mass and Channing, 73.6 miles to the southeast. The railroad provided living quarters for the station agent and his family on the depot's second floor. (Dave Tinder collection.)

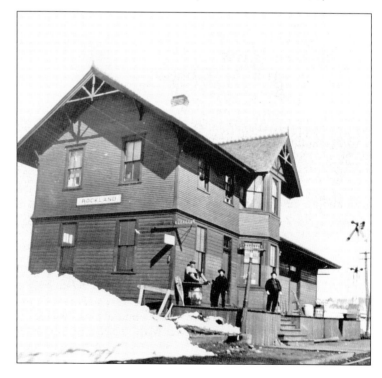

79

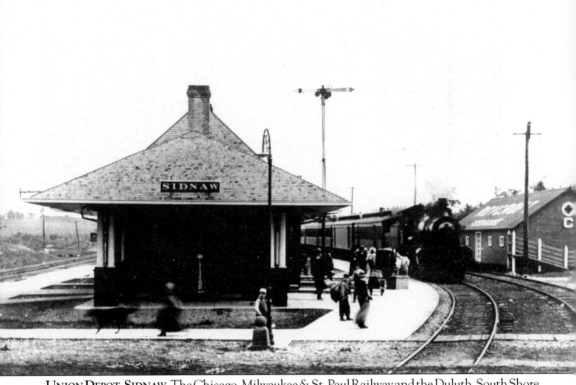

UNION DEPOT, SIDNAW. The Chicago, Milwaukee & St. Paul Railway and the Duluth, South Shore & Atlantic Railway both used Sidnaw Union Depot. This small Houghton County community became a two-railroad town in October 1889, when the Ontonagon & Brule River Railroad (a Chicago, Milwaukee & St. Paul predecessor) completed its line down from Ontonagon. The Marquette, Houghton & Ontonagon Railroad (a Duluth, South Shore & Atlantic predecessor) had arrived in September of the previous year, with its line between St. Ignace and Superior, Wisconsin. The Milwaukee & Northern Railroad bought the Ontonagon & Brule River and completed the line from Sidnaw to Channing in January 1893. According to their May 1920 timetables, the Duluth, South Shore & Atlantic ran a pair of overnight trains between Duluth/Superior and St. Ignace/Sault Ste. Marie, which met in Sidnaw at 2:17 a.m. A pair of daylight trains between Marquette and Duluth/Superior were also offered. On the Chicago, Milwaukee & St. Paul side, two pairs of trains were operated—one between Ontonagon and Chicago, Illinois, and a second pair between Ontonagon and Channing. (Dave Tinder collection.)

80

CHICAGO, MILWAUKEE & ST. PAUL DEPOT, WITCH LAKE. When the St. Paul Road completed its line from the Michigan/Wisconsin state line to Champion in November 1882, its right-of-way skirted the shores of Witch Lake. In the summer of 1920, depot facilities at Witch Lake were rather spartan and only saw activity if the two local trains were flagged down for passengers. (Dave Tinder collection.)

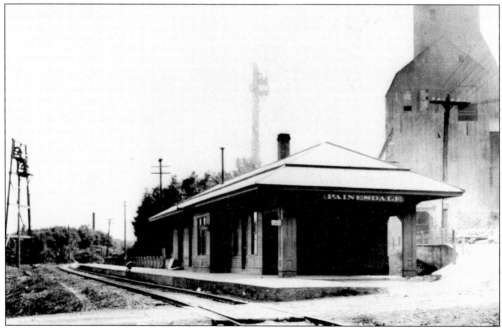

COPPER RANGE DEPOT, PAINESDALE. In addition to its regular trains, the Copper Range Railroad also ran a school train to Painesdale for high school students. Each school day, the train left Freda at 6:25 a.m. and arrived in Painesdale at 7:15 a.m. The train also picked up students from Atlantic, Redridge, and South Range. The return trip left Painesdale at 2:45 p.m. and was back in Freda an hour later. (Dave Tinder collection.)

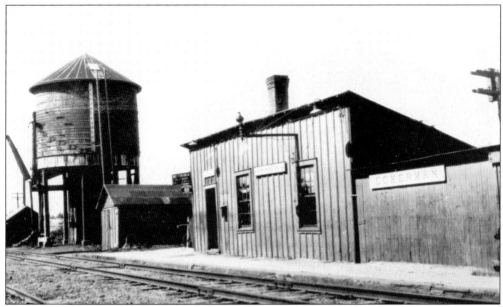

DULUTH, SOUTH SHORE & ATLANTIC DEPOT, ECKERMAN. The railroad reached Eckerman in October 1887 when the 47-mile line from Soo Junction to Sault Ste. Marie was completed. Eckerman had a 1920 population of 25, so station facilities at this lumbering outpost were minimal. According to its April 1920 timetable, four trains served the community each business day—three making regularly scheduled stops and one a flag stop. (James Harlow collection.)

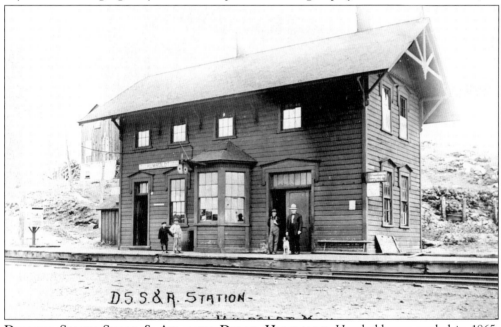

DULUTH, SOUTH SHORE & ATLANTIC DEPOT, HUMBOLDT. Humboldt was settled in 1865, with the coming of the railroad and the opening of the Edwards Mine. Located 27 miles west of Marquette, on the railroad's Sault Ste. Marie to Duluth, Minnesota, main line, this community was named for its close proximity to the Humboldt Range. The large two-story depot likely provided living quarters for the agent and his family. (Dave Tinder collection.)

82

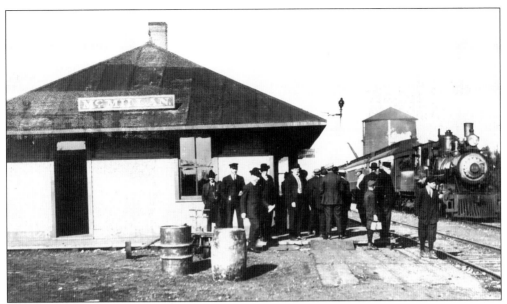

DULUTH, SOUTH SHORE & ATLANTIC DEPOT, MCMILLAN. Despite being 63 miles west of St. Ignace, McMillan was shown in the railroad's 1920 timetable as milepost 67. The reason was simple. When the railroad through McMillan was built in 1880 and 1881, it was a Marquette-to-St. Ignace project. Six years later, when the Sault Ste. Marie line was completed, the mile markers were revised to reflect the distance from the Soo. (Dave Tinder collection.)

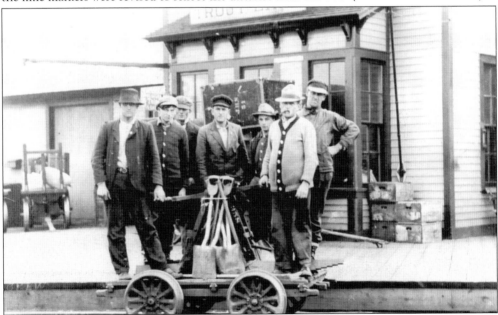

UNION DEPOT, TROUT LAKE. A section crew is shown posing on its handcar in front of the depot at Trout Lake. The Detroit, Mackinac & Marquette Railroad (a Duluth, South Shore & Atlantic Railway predecessor) was the first railroad to arrive in December 1881, with its line between Marquette and St. Ignace. Seven years later, the Minneapolis, St. Paul & Sault Ste. Marie Railway completed its line through Trout Lake and on to Sault Ste. Marie. (Dave Tinder collection.)

83

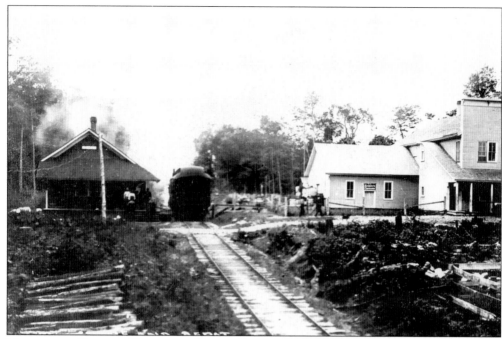

MANISTIQUE RAILWAY DEPOT AND TRAIN, CURTIS. Over the course of 21 years, between 1886 and 1906, the Manistique Railway built a 32-mile main line between Seney and Grand Marais, and a 21-mile branch line from Seney southeast to Wilman via Curtis. By 1910, the railway had sold its Grand Marais line to the Manistique Lumber Company and the Curtis Branch to the Escanaba Lumber Company. (Dave Tinder collection.)

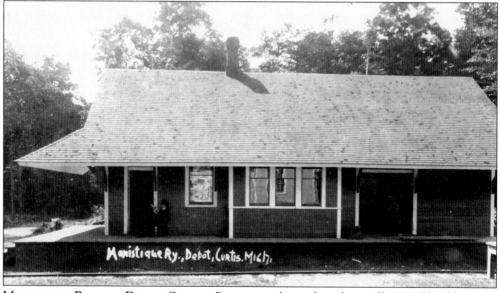

MANISTIQUE RAILWAY DEPOT, CURTIS. Portage was located on the small strip of land between Manistique Lake and Whitefish Lake. Following the completion of the railroad as far as Portage in November 1904, the community was renamed Curtis in honor of state senator William Curtis of Petoskey. Two years later, the branch line was extended another 2.8 miles to Wilman. The well-maintained station at Curtis is shown above. (Dave Tinder collection.)

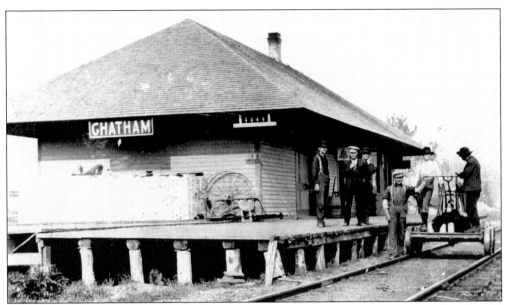

MUNISING, MARQUETTE & SOUTHEASTERN DEPOT, CHATHAM. Chatham was located on the Munising, Marquette & Southeastern Railway's line to Princeton, 17.3 miles southwest of the city of Munising. In addition to the service between Princeton and Munising, convenient connections were built into the schedule at Lawson for those traveling to Marquette. Train No. 1 and No. 4 continued beyond Marquette to Negaunee and Ishpeming. Leaving Chatham at 8:12 a.m., one could be in Ishpeming (55 rail miles away) by 11:00 a.m. (Dave Tinder collection.)

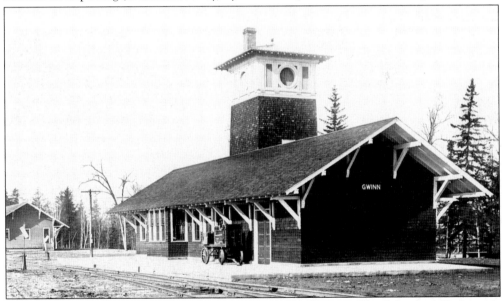

MUNISING, MARQUETTE & SOUTHEASTERN DEPOT, GWINN. The Munising Railway (a Munising, Marquette & Southeastern predecessor) built its main line to Princeton in two segments. In 1897, the 38-mile Munising-to-Little Lake section was completed, where a connection was made with the Chicago & North Western Railway. The seven-mile Little Lake-to-Princeton segment was completed via Gwinn in 1906. Gwinn saw four passenger trains each business day according to the railroad's June 1920 timetable. (Dave Tinder collection.)

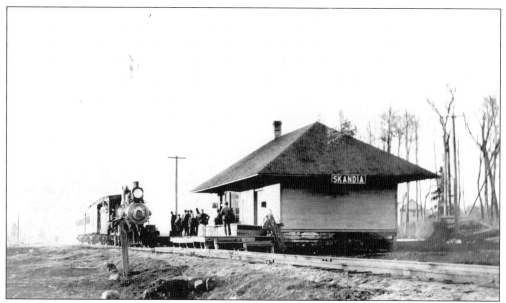

Munising, Marquette & Southeastern Depot, Skandia. The Marquette & Southeastern Railway (a Munising, Marquette & Southeastern Railway predecessor) completed its line between Marquette and Lawson in 1905. Skandia was located 20.8 miles southeast of Marquette and had a population of 200 in 1920. The community was served by this small, hip-roofed, combination station that was nearly totally devoid of any architectural embellishment. One of the four daily-except-Sunday accommodation trains is shown arriving at Skandia. (Dave Tinder collection.)

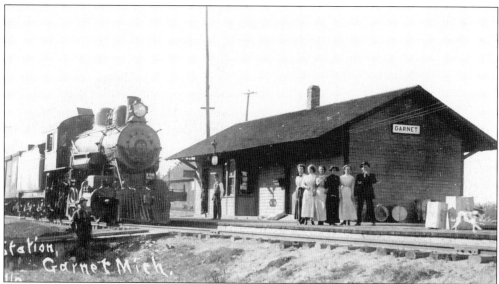

Minneapolis, St. Paul & Sault Ste. Marie Depot, Garnet. Known previously as Welch, Garnet was located 58.4 miles west of Sault Ste. Marie on the railroad's Minneapolis, Minnesota, to Sault Ste. Marie main line, completed in January 1888. Nine years later, a settlement grew up around the Donaldson & Hudson sawmill and general store. The Garnet station was a standard company design, featuring a low gable roof, bay window, and minimal exterior ornamentation. (Dave Tinder collection.)

86

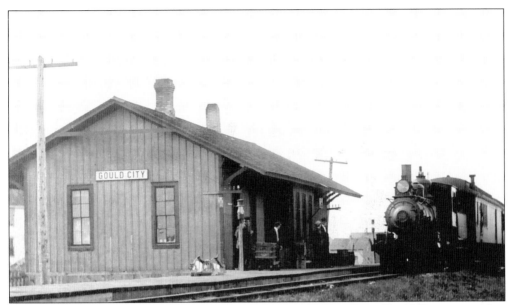

MINNEAPOLIS, ST. PAUL & SAULT STE. MARIE DEPOT, GOULD CITY. Gould City was another lumbering town served by the railroad and was located 19.8 miles west of Garnet. In 1920, despite the community's population of only 150 people, all four main line trains made regularly scheduled stops here. In addition, there was a pair of passenger-carrying freight trains, which operated between Trout Lake and Gladstone. (Dave Tinder collection.)

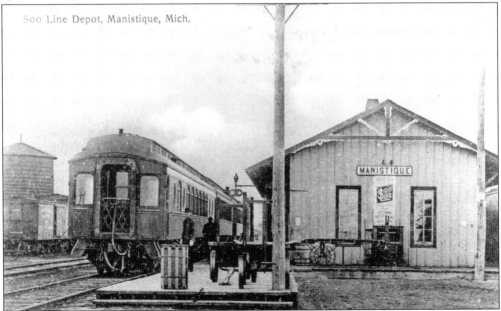

MINNEAPOLIS, ST. PAUL & SAULT STE. MARIE DEPOT, MANISTIQUE. Founded in 1871 by Henry Schoolcraft, Manistique was named after the Ojibway Indian word for the nearby river, the correct spelling of which was actually Monastique. With a population of 5,000 residents, Manistique had become a major source of revenue for the railroad's Wisconsin & Peninsula Division by 1920. During the postcard era, the community was served by this wood frame station. (James Harlow collection.)

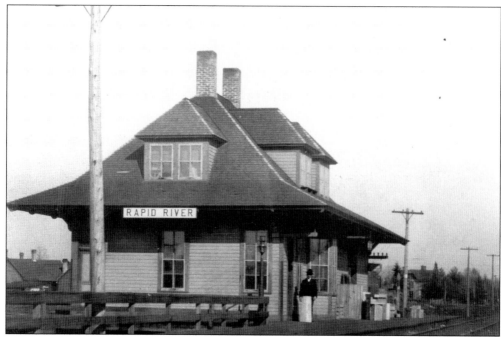

MINNEAPOLIS, ST. PAUL & SAULT STE. MARIE DEPOT, RAPID RIVER. In April 1920, Rapid River was the first passenger train stop east of Gladstone. At that time, travel options into or out of Rapid River were rather limited, with only four trains making regularly scheduled stops here. The depot was nonetheless an impressive-looking wood frame structure, with living quarters on the second floor for the station agent and his family. (James Harlow collection.)

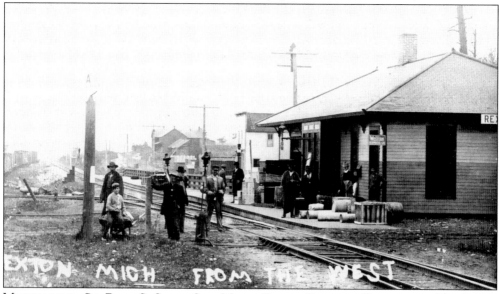

MINNEAPOLIS, ST. PAUL & SAULT STE. MARIE DEPOT, REXTON. Quarrying and lumbering were the heart and soul of this small Mackinac County community in the early years of the 20th century. A series of branch lines leaving the main line at Rexton served the Hendricks and Mead quarries, as well as the D. N. McLeod Lumber Company. This hip-roof depot of standard company design served Rexton's 200 residents in 1920. (Dave Tinder collection.)

Five

NOT OTHERWISE ACCOUNTED FOR

In 1914, with steam and electric interurban railroads operating 9,711 miles of track in the state, Michigan's railroad map resembled a plate of spaghetti. Main lines and branch lines blanketed both peninsulas, but the track network was particularly dense in the southern portion of the Lower Peninsula.

Not surprisingly, given the large number of railroads and predecessor companies, there was a rich variety of station designs utilized in the Lower Peninsula. Since many of the structures were located on branch or secondary lines, wood was often deemed to be the most cost-effective building material for most companies. But many railroads and the communities they served were not content with wood frame structures that were totally devoid of "style." To this end, various architectural embellishments (some very simple and others a bit more complex) were used to "spice up" these small wood frame depots. Included were roof finials, sculptured wood trim above window and door openings, end wall attic windows, mixtures of horizontal and vertical wood siding, decorative support brackets under the eaves, and two-tone paint jobs. Roof dormers and intersecting rooflines were more costly extras and were also utilized to give a small-town depot even more style.

The Detroit, Hillsdale & Indiana Rail Road (a Lake Shore & Michigan Southern Railway predecessor) utilized contrasting trim paint, curved brackets under the eaves, and half-moon-shaped attic windows to good advantage in enhancing the appearance of its wood frame depot at Brooklyn. The Michigan Air Line Railway (a Grand Trunk Railway predecessor) took the embellishment process a step further on its depot at Stockbridge. Here, designers utilized intersecting gable roof sections, decorative roof finials, gingerbread gable trim, a built-out bay window, a bracket-supported porch over the doorway, vertical wood siding, and a contrasting wood trim color to produce a small-town depot of exceptional beauty. Apparently, Michigan Air Line officials were impressed with this attractive station design as well, since it was used at several other locations on its Pontiac-to-Jackson line.

NOT OTHERWISE ACCOUNTED FOR

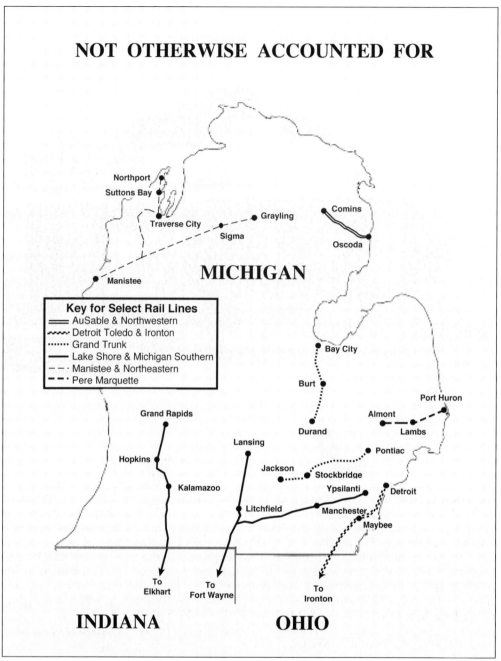

Key for Select Rail Lines
- AuSable & Northwestern
- Detroit Toledo & Ironton
- Grand Trunk
- Lake Shore & Michigan Southern
- Manistee & Northeastern
- Pere Marquette

NOT OTHERWISE ACCOUNTED FOR. Branch and secondary line station design varied considerably by company, adding a diverse richness to railroad architecture in Michigan's Lower Peninsula.

90

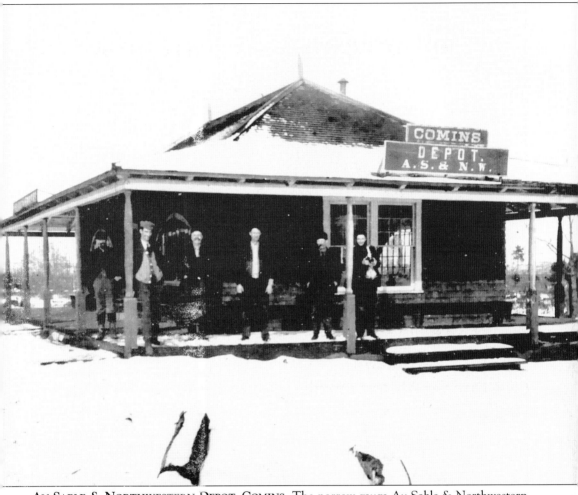

AU SABLE & NORTHWESTERN DEPOT, COMINS. The narrow-gauge Au Sable & Northwestern Railroad had its origins in 1887 as a private railroad serving the J. E. Potts Salt & Lumber Company. Common carrier status was achieved two years later when it established a connection with the narrow-gauge Detroit, Bay City & Alpena Railroad. In 1891, Potts sold the operation to H. M. Loud, who built several new branches and extended the main line to Comins and Lewiston. Unfortunately, the good times did not last and the railway contracted nearly as fast as it had grown. In January 1906, it ceased operating, but Loud's heirs revived the railroad's charter in December 1907, with Comins as the operational headquarters. In 1912, the struggling railroad was leased to the Detroit & Mackinac Railway, which purchased it outright two years later. The remaining trackage was converted to standard gauge in 1915. Operated as its Au Sable River Division, the Detroit & Mackinac ran daily-except-Sunday passenger service between Au Sable and Comins. In addition, service was also offered on the short four-mile branch line between Hardy and Curran. (Dave Tinder collection.)

91

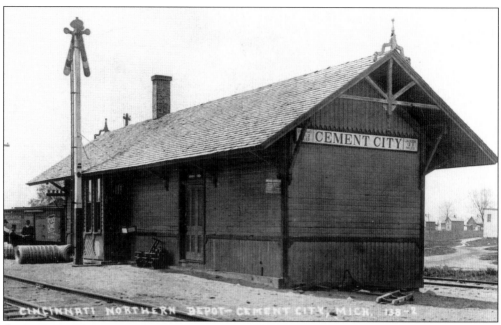

CINCINNATI NORTHERN DEPOT, CEMENT CITY. In its first 21 miles south of Jackson, the Cincinnati Northern Railroad line passed in close proximity to four major lakes—Ackerson, Clarks, Goose, and Devils Lakes. Cement City and nearby Goose Lake were located 13.5 miles south of the home terminal. Known alternately as Woodstock and Kelly's Corners, the community was renamed Cement City in 1901 after the Peninsular Portland Cement Company plant placed in operation here. (James Harlow collection.)

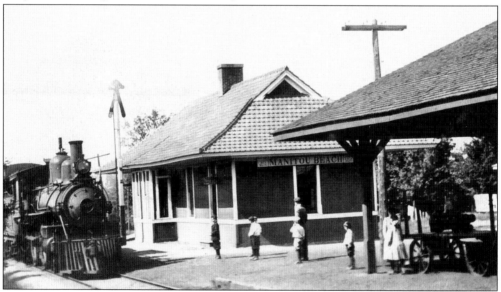

CINCINNATI NORTHERN DEPOT, MANITOU BEACH. According to its timetable dated May 23, 1920, one could board train No. 17 in Jackson at 10:16 a.m. and be in Manitou Beach at 11:02 a.m., leaving four hours to swim, play, or relax at the beach. Train No. 16 departed Manitou Beach at 3:07 p.m. and had its passengers back in Jackson at 4:00 p.m., relaxed and refreshed. (James Harlow collection.)

92

CINCINNATI NORTHERN DEPOT, ROLLIN. The Cincinnati Northern operated a modest passenger service in May 1920. Train No. 16 and No. 17 ran daily-except-Sunday between Jackson and Cincinnati, Ohio, 245 miles to the south. In addition, train No. 1 and No. 2 covered the 103 miles between Jackson and Van Wert, Ohio, with schedules that provided Rollin residents six hours business time in Jackson. (James Harlow collection.)

CLEVELAND, CINCINNATI, CHICAGO & ST. LOUIS DEPOT, SODUS. This community was located 7.1 miles south of Benton Harbor. In 1882, the Chicago, Wabash & Michigan Railway (a Cleveland, Cincinnati, Chicago & St. Louis Railway predecessor) completed the northern end of this 249-mile line from North Vernon, Indiana, to Benton Harbor via Elkhart, Indiana. Trackage rights on the Baltimore & Ohio Railroad made this a direct route to Louisville, Kentucky. (James Harlow collection.)

93

Detroit, Toledo & Ironton Depot, Maybee. When this photograph was taken, the Detroit, Toledo & Ironton Railroad station at Maybee was very characteristic of Lake Shore & Michigan Southern Railway designs. In November 1897, the Detroit & Lima Northern Railway (a Detroit, Toledo & Ironton predecessor) purchased the Chandler (just south of Trenton) to Dundee portion of the former Chicago & Canada Southern Railway from successor Lake Shore & Michigan Southern, as a means of piecing together its own route into Detroit. It was a roundabout way of gaining access to the city that went by way of Adrian and Tecumseh, and still required 16.1 miles of trackage rights over the Lake Shore & Michigan Southern between Tecumseh and Dundee. While technically outside the time frame of this work, it is interesting to note that Henry Ford did complete a more direct route into Detroit in 1926. The new line ran between Durban (just south of Maybee) and Malinta, Ohio. Known as the Malinta Cutoff, the new line was 20.5 miles shorter than the old route, eliminated 41 curves, and reduced overall gradient. (James Harlow collection.)

94

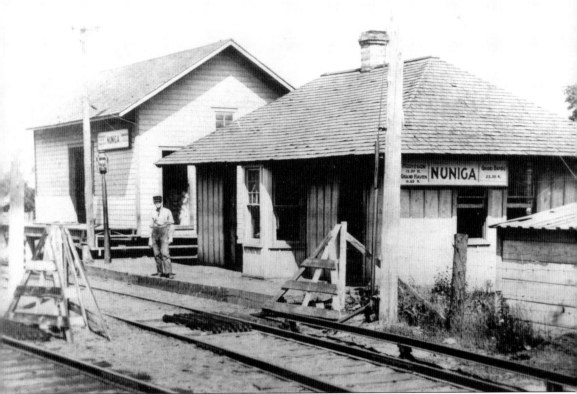

GRAND RAPIDS, GRAND HAVEN & MUSKEGON DEPOT, NUNICA. This electric interurban railway began operations in February 1902, and connected its namesake cities with 42 miles of third rail–powered trackage. Its timetables dated June 24, 1920, showed limited and local service operating every two hours, from approximately 7:00 a.m. to 6:00 p.m., with reduced service during the evening. In addition to its regularly scheduled trains, the company also offered unique triangle excursion packages with the Crosby and Goodrich steamship lines operating on Lake Michigan. Excursionists rode the interurban from Grand Rapids to Muskegon, boarded a steamship there for the trip to Grand Haven, and then boarded an interurban car for the return trip to Grand Rapids. While the third rail eliminated the need for maintaining overhead wires, sleet and heavy snow storms often wreaked havoc with the power rail. It has been said that it was not unusual to see railway employees riding on the car fenders scraping ice off the third rail power source. With the rigors of winter behind, the Grand Rapids, Grand Haven & Muskegon Railway station at Nunica, 20 miles west of Grand Rapids, is shown on a clear summer day. (James Harlow collection.)

95

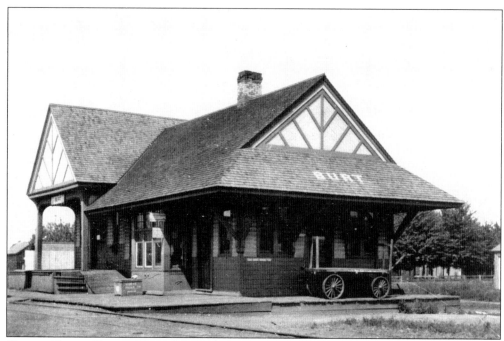

GRAND TRUNK DEPOT, BURT. The Toledo, Saginaw & Mackinaw Railroad (a Grand Trunk Railway predecessor) completed its line from Durand to Saginaw in 1888. Two years later, the remaining 19.7 miles were put in service to Oa-at-Ka Beach, just north of Bay City. Burt was located 25.4 miles north of Durand and was served by this attractive wood frame depot, a design also utilized at Lennon. (James Harlow collection.)

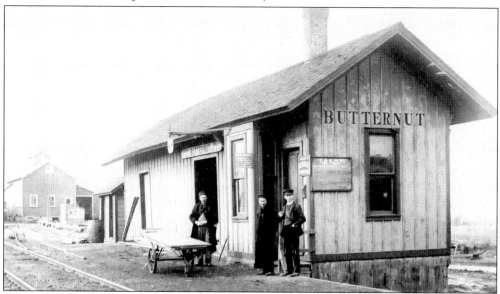

GRAND TRUNK DEPOT, BUTTERNUT. Butternut was located 43 miles west of Owosso on the Grand Trunk's Owosso-to-Muskegon line. Passenger accommodations appear rather limited at this station, with most of the floor space devoted to the freight side of the business. A pair of trains (No. 41 and No. 42) based out of Muskegon provided daily-except-Sunday service on the line. Butternut was named for the butternut cheese factory located here. (Dave Tinder collection.)

96

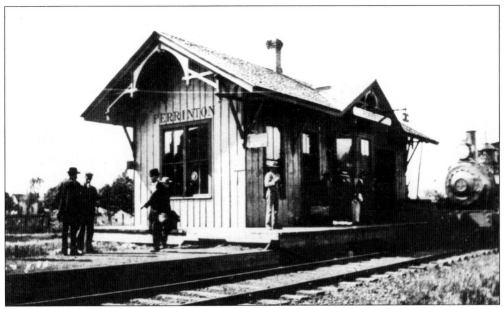

GRAND TRUNK DEPOT, PERRINTON. Construction crews completed the Toledo, Saginaw & Muskegon Railway line between Ashley and Carson City via Perrinton in September 1887. It would take nearly another year for the line to be completed to Muskegon. Pictured above is the first depot built at Perrinton. The Toledo, Saginaw & Muskegon was controlled by the Grand Trunk but was not formally merged into that system until November 1928. (James Harlow collection.)

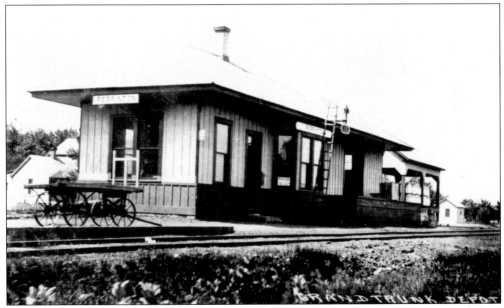

GRAND TRUNK REPLACEMENT DEPOT, PERRINTON. Perrinton was incorporated as a village in 1891, a few years after the arrival of the railroad. A replacement depot was built here at some point during the postcard era. While it was larger and more accommodating than its predecessor, the new station was rather plain looking and lacked the charm of the first depot. (James Harlow collection.)

GRAND TRUNK DEPOT, STOCKBRIDGE. Stockbridge was located 87.6 miles west of Richmond on the Michigan Air Line Railway (a Grand Trunk Railway predecessor). The line was completed only as far as Jackson in September 1884, but the company had visions of building all the way to Chicago. This attractive depot design was duplicated at Orchard Lake, Walled Lake, and New Hudson. (James Harlow collection.)

LAKE SHORE & MICHIGAN SOUTHERN DEPOT, BROOKLYN. According to New York Central Railroad (a Lake Shore & Michigan Southern Railway successor) Lansing Division employee timetable No. 10, dated October 26, 1919, Brooklyn was served by a pair of first-class locals, train No. 51 and No. 52, and a pair of second-class mixed trains, No. 53 and No. 54. The two mixed trains met here at 2:20 p.m. each business day. (James Harlow collection.)

LAKE SHORE & MICHIGAN SOUTHERN DEPOT, BYRON CENTRE. According to the railroad's Michigan Division employee timetable No. 10, dated May 31, 1908, there were four passenger and six freight trains operating between Grand Rapids and White Pigeon. At the Byron Centre station, there was one scheduled meet, where northbound freight train No. 552 took the siding, to allow northbound passenger train No. 510 to pass at 5:18 p.m. (James Harlow collection.)

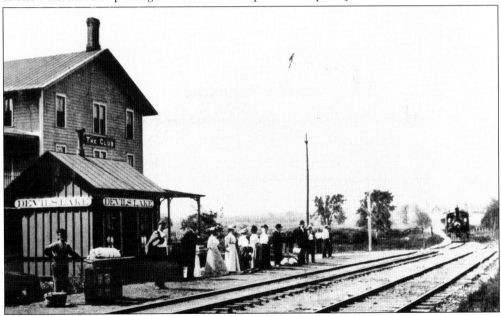

LAKE SHORE & MICHIGAN SOUTHERN DEPOT, DEVILS LAKE. Devils Lake was one of the main tourist draws on the Michigan & Ohio Railroad (a Lake Shore & Michigan Southern predecessor). The tracks skirted the north side of the lake, but in 1908, there were no attractive depot facilities to welcome visitors. Passengers likely waited for their trains in "the club" immediately behind the small depot. (James Harlow collection.)

99

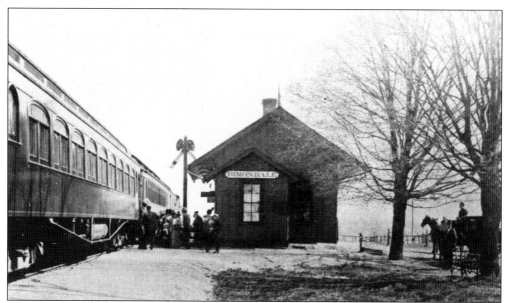

LAKE SHORE & MICHIGAN SOUTHERN DEPOT, DIMONDALE. Dimondale was a station on the Hillsdale-to-Lansing line, completed by the Northern Central Michigan Railway (wholly owned by the Lake Shore & Michigan Southern Railway) in 1873. Isaac Dimon built a saw- and gristmill on the Grand River here and named the community after himself in 1856. This was a standard Lake Shore depot design and was used at several other locations. (James Harlow collection.)

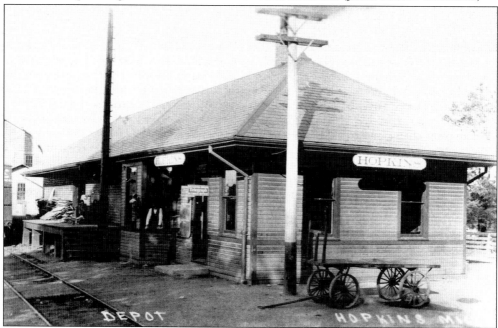

LAKE SHORE & MICHIGAN SOUTHERN DEPOT, HOPKINS. While Hopkins was not formally incorporated as a village until 1920, the community had been served by rail since March 1869, when the White Pigeon-to-Grand Rapids line was completed. Hopkins was located 25.4 miles south of Grand Rapids and was served by four daily-except-Sunday trains running between Grand Rapids and Elkhart, Indiana. (James Harlow collection.)

100

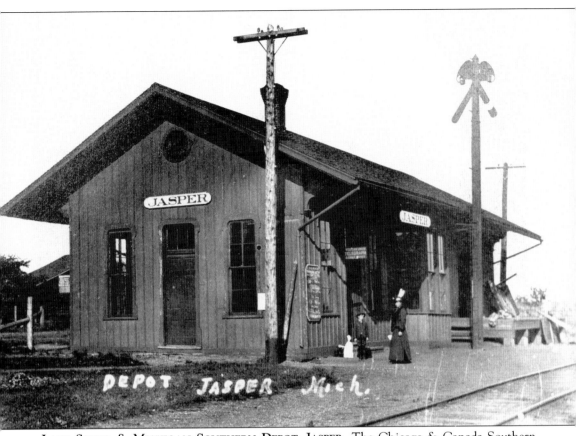

LAKE SHORE & MICHIGAN SOUTHERN DEPOT, JASPER. The Chicago & Canada Southern Railway (a Lake Shore & Michigan Southern predecessor) planned a through route between Buffalo, New York, and Chicago, Illinois, bypassing Detroit. The railroad through Canada crossed the Detroit River by car ferry at Grosse Ile and proceeded southwest through Carleton, Dundee, Grosvenor, Jasper, and Morenci. The project was only completed as far as Fayette, Ohio, before plans changed in 1883 and Detroit was put back on the route. In the 1890s, portions of the now redundant rail line were sold off or abandoned outright. One of the remnants was the 25-mile Fayette Branch between Grosvenor and Fayette, acquired in a lease arrangement by the Lake Shore & Michigan Southern. In the summer of 1920, Jasper was served by two pairs of daily-except-Sunday trains, which ran between Fayette and Adrian. The 7:04 a.m. departure from Jasper allowed those traveling to Adrian a full day for shopping or conducting business before the return train left at 4:55 p.m. (James Harlow collection.)

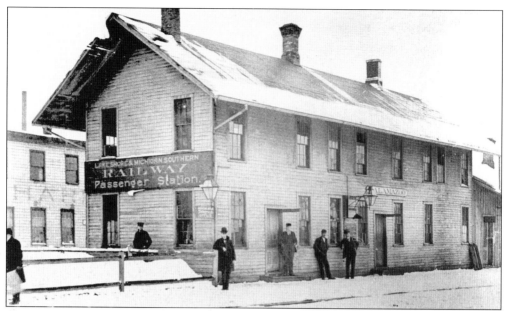

LAKE SHORE & MICHIGAN SOUTHERN DEPOT, KALAMAZOO. The Lake Shore & Michigan Southern Railway's Grand Rapids Branch was completed in 1869, when the Kalamazoo, Allegan & Grand Rapids Rail Road (a Lake Shore & Michigan Southern predecessor) finished the final 33.2 miles of line into Grand Rapids. This two-story wood frame structure above served as the railway's depot until January 1915, when the New York Central Railroad assumed ownership of the property. (James Harlow collection.)

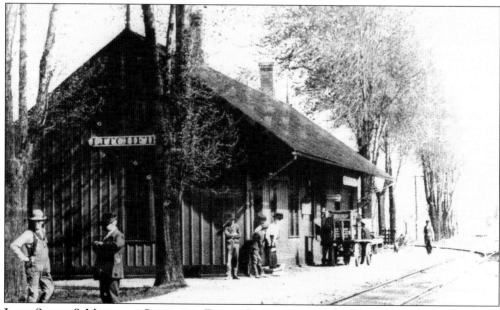

LAKE SHORE & MICHIGAN SOUTHERN DEPOT, LITCHFIELD. Litchfield was located 12 miles north of Hillsdale on the railway's Lansing Branch. In the summer of 1920, the Lake Shore was providing morning and afternoon departures out of both Hillsdale and Lansing. The daily-except-Sunday trains departed Litchfield's wood frame station at 8:22 a.m. northbound, 10:56 a.m. southbound, 2:41 p.m. northbound, and 5:49 p.m. southbound. (James Harlow collection.)

102

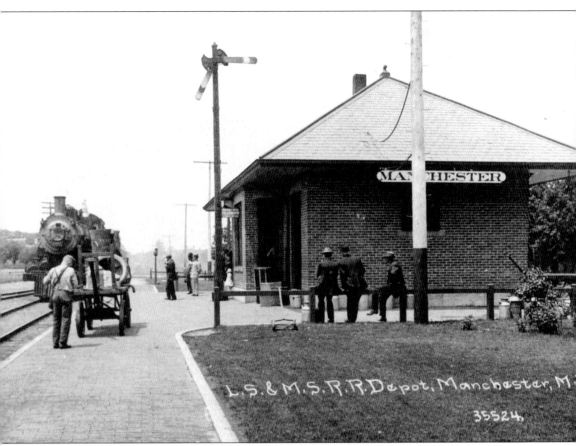

LAKE SHORE & MICHIGAN SOUTHERN DEPOT, MANCHESTER. The Lake Shore & Michigan Southern's Jackson Branch and Ypsilanti Branch crossed one another northwest of town, at a place called Manchester Junction. The Manchester depot was located on Jackson Branch trackage, 0.6 miles southeast of the junction. All Ypsilanti Branch trains were forced to make a backup move coming into or leaving the station. Eastbound trains bound for Ypsilanti pulled into the station and backed out, while westbound trains backed into the station and pulled out. When unencumbered by other train movements, the backup moves could be completed in two to three minutes. Despite the fact that both lines were considered branches, their normal freight and passenger traffic, plus the Ypsilanti Branch backup moves, made Manchester a busy place. According to Lake Shore & Michigan Southern Detroit Division employee timetable No. 14B, dated October 16, 1910, the brick depot at Manchester saw 10 Jackson Branch and six Ypsilanti Branch trains each business day. (James Harlow collection.)

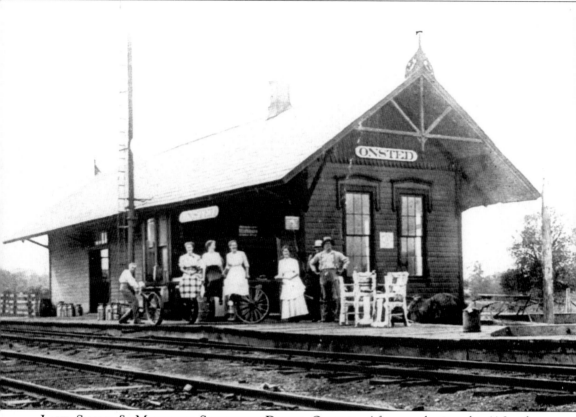

LAKE SHORE & MICHIGAN SOUTHERN DEPOT, ONSTED. After purchasing the 11.2-mile Allegan & South Eastern Railroad, building 121.7 miles of its own trackage between Montieth and Dundee by way of Onsted, and obtaining trackage rights over the Toledo, Ann Arbor & North Michigan Railway south of Dundee, the Michigan & Ohio Railroad (a Lake Shore & Michigan Southern Railway predecessor) had put together a direct route between Allegan and Toledo, Ohio, in November 1883. Unfortunately, it appears that there was not enough traffic to support the line once it had been built. The company was reorganized and renamed several times over the next two decades. In 1905, the company (now known as the Detroit, Toledo & Milwaukee Railroad) was split at Moscow, with the western portion of the line being leased by the Michigan Central Railroad, and the eastern portion (including the trackage through Onsted) going to the Lake Shore & Michigan Southern. Further change took place in 1913, when the Allegan-to-Battle Creek portion was sold to the Michigan & Chicago Railway, and was converted into an electric interurban operation. (James Harlow collection.)

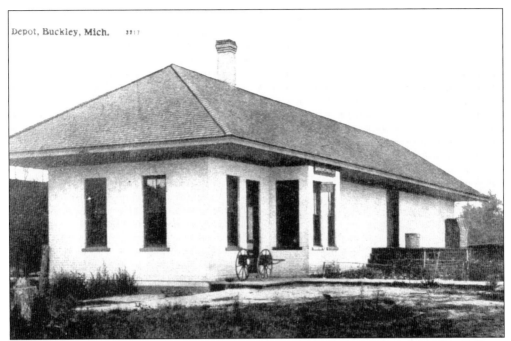

Depot, Buckley, Mich.

MANISTEE & NORTHEASTERN DEPOT, BUCKLEY. Buckley was located on the railroad's River Branch, which ran from River Branch Junction (1.4 miles northeast of Kaleva) to Grayling. Located 23.8 miles east of Kaleva, this community was named after the Buckley & Douglas Lumber Company. In its timetable dated June 27, 1920, train No. 51 and No. 52 were providing daily-except-Sunday service between Manistee and Grayling. (James Harlow collection.)

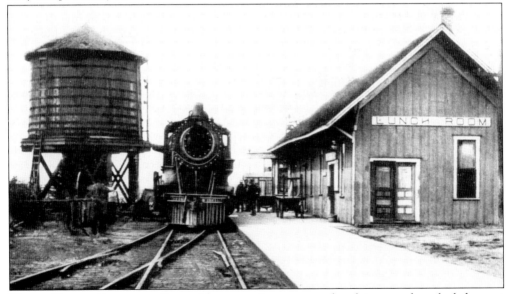

UNION DEPOT, COPEMISH. Copemish was an important railroad town and marked the spot where the Ann Arbor Railroad, the Manistee & Northeastern Railroad, and the Arcadia & Betsey River Railway converged. The Ann Arbor and the Manistee & Northeastern were still providing service in 1920, but the Arcadia & Betsey River had already abandoned its line between Copemish and Henry. (James Harlow collection.)

105

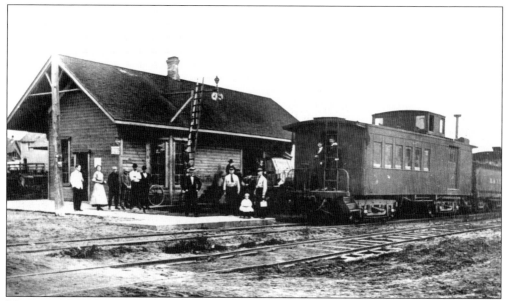

MANISTEE & NORTHEASTERN DEPOT, HONOR. The Manistee & Northeastern Railroad's 16.8-mile Platte River Branch via Honor was the Empire & South Eastern Railroad's sole connection. In 1920, service on the branch was sparse and operation was limited to Tuesdays and Fridays. Surprisingly, connecting service was available at Empire Junction for those making the trip into Empire. Patience and a good book were all that was required. (James Harlow collection.)

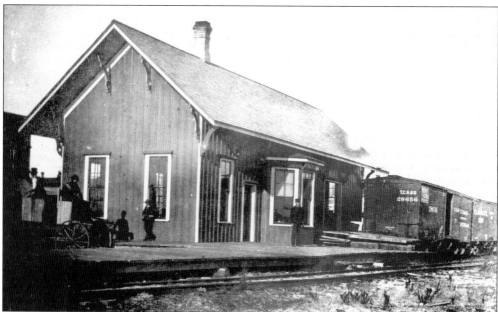

MANISTEE & NORTHEASTERN DEPOT, ONEKAMA. The 2.8-mile branch to Onekama was built in the first wave of Manistee & Northeastern construction in 1888 and 1889, which saw the railroad complete 36.2 miles of trackage. Once the trains were generating revenue by supplying the lumber mills with logs, some of the financial pressure was taken off the company to complete its line north to Traverse City. (James Harlow collection.)

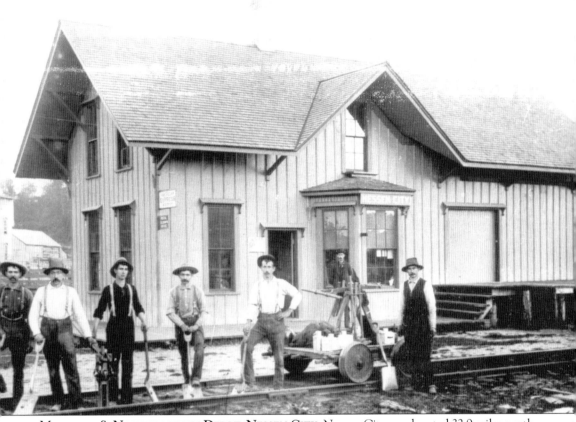

MANISTEE & NORTHEASTERN DEPOT, NESSEN CITY. Nessen City was located 32.9 miles north of Manistee on the railroad's main stem to Traverse City. The line was completed as far as Nessen City in November 1888, and by the following month, the railroad was running two log trains per day into Manistee. This community developed as a direct result of the Manistee & Northeastern being built. John Nessen and his wife Edith purchased 160 acres of land here and in 1889 opened a sawmill to produce lumber from the excellent hardwood growing in the area. He also built a hotel and opened a store in the village that bore his name. The town's and the railroad's prosperity were both tied directly to the availability of timber. Unfortunately, the fortunes of the Manistee & Northeastern had begun to fade and by 1917, the railroad was experiencing serious financial difficulties. (James Harlow collection.)

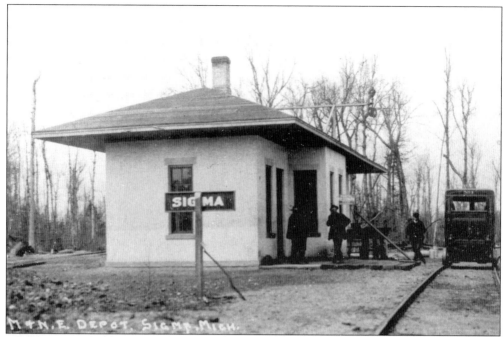

MANISTEE & NORTHEASTERN DEPOT, SIGMA. Sigma was located 61 miles east of Kaleva and was named after a letter in the Greek alphabet. As timber resources dwindled around Manistee, the company extended its River Branch east to Grayling in 1909 and 1910, to open up the forests in Kalkaska County. A pair of daily-except-Sunday trains served Sigma at 12:56 p.m. eastbound and 2:42 p.m. westbound. (James Harlow collection.)

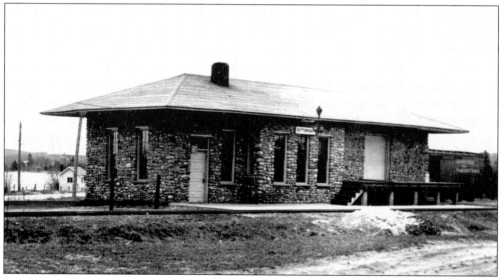

MANISTEE & NORTHEASTERN DEPOT, SUTTONS BAY. When the Traverse City, Leelanau & Manistique Railroad (a Manistee & Northeastern Railroad predecessor) completed its line between Hatch's Crossing (5.2 miles west of Traverse City) and Northport in June 1903, the company built two nearly identical fieldstone depots at Suttons Bay and Northport. According to its June 1920 timetable, Suttons Bay was served by four trains each business day. (James Harlow collection.)

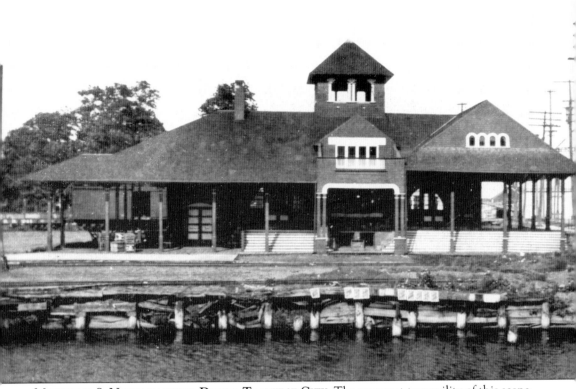

MANISTEE & NORTHEASTERN DEPOT, TRAVERSE CITY. The apparent tranquility of this scene at the Traverse City station is somewhat misleading. Less than a month after its summer timetable was published on June 27, 1920, the financially ailing company was dealt another serious blow when the mill complex at Manistee was destroyed in a spectacular fire on July 22. It was the second largest fire in the city's history, consuming the lumber mill, the salt plant, the railroad shops, and several locomotives. The salt plant was eventually rebuilt, but the railroad's revenues took another hit the following year, when potato shipments were drastically reduced. Despite the best efforts of its receiver, the company never was able to regain stability, and a petition for abandonment was filed with the Interstate Commerce Commission in 1924. The following year, the River Branch to Grayling was abandoned, and in January 1926, the remaining trackage was sold to James Daggett for $300,000. (James Harlow collection.)

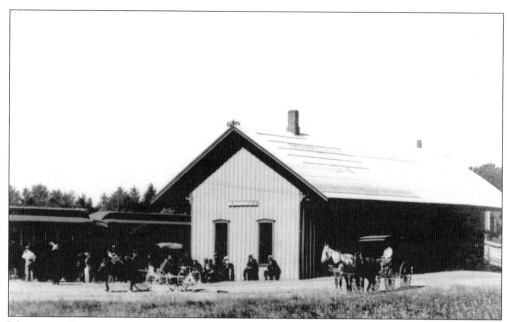

MICHIGAN CENTRAL DEPOT, BLOOMINGDALE. The Kalamazoo & South Haven Rail Road (a Michigan Central Railroad predecessor) ran its first train into Bloomingdale on July 4, 1870, with the balance of the line to South Haven being completed in January 1871. The wood frame depot was built in December 1870 by the Howard brothers (Harvey, Joseph, and Zenas) on an acre of land donated by August Haven. (James Harlow collection.)

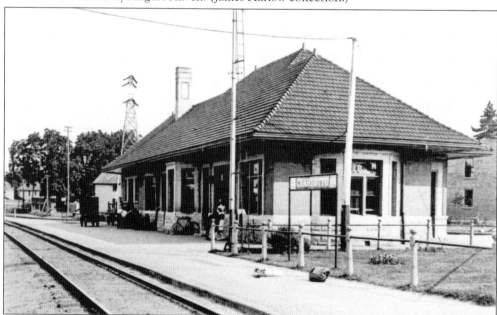

MICHIGAN CENTRAL DEPOT, CHARLOTTE. Charlotte was ultimately served by two substantial station buildings. The Chicago & Grand Trunk Railway (a Grand Trunk Railway predecessor) built an attractive all-brick station here in 1885. Then, the Michigan Central followed up in 1902 with this even larger brick and sandstone depot. In the summer of 1920, Charlotte was served by 20 trains each business day, split evenly between the two railroads. (James Harlow collection.)

110

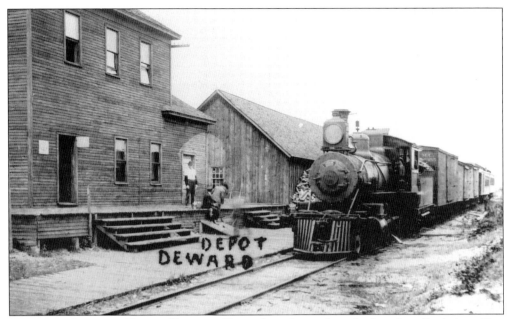

MICHIGAN CENTRAL DEPOT, DEWARD. Deward was located on the line from Frederic to East Jordan, built by the Detroit & Charlevoix Railroad (a Michigan Central predecessor) in 1901. The heirs of David Ward's vast timber estate were responsible for naming this station, and they operated a sawmill here until 1912. In 1920, the Michigan Central was operating a pair of trains over the line, which were based out of East Jordan. (James Harlow collection.)

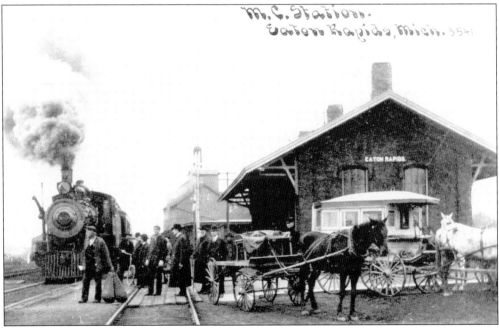

MICHIGAN CENTRAL DEPOT, EATON RAPIDS. The timetable may have read Grand Rapids Branch, but the number of trains serving Eaton Rapids in June 1920 would have rivaled the schedule pages for some main lines. The Michigan Central offered five weekday round-trips between Grand Rapids and Jackson, four of which were also run on Sunday. (James Harlow collection.)

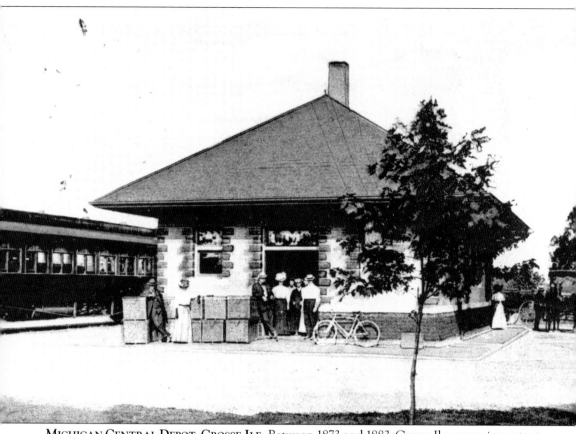

MICHIGAN CENTRAL DEPOT, GROSSE ILE. Between 1873 and 1883, Grosse Ile was an important location on a through freight route between Buffalo, New York, and Chicago, Illinois. To accommodate the trains, two bridges were built—one connecting Grosse Ile to the mainland and a second connecting Grosse Ile with Stony Island. From Stony Island, the trains were ferried across the Detroit River to a slip at Gordon, just north of Amherstburg, Ontario. When the Michigan Central Railroad's Essex-to-Windsor, Ontario, line was completed in 1883, car ferry service began between Windsor and Detroit. At that time, the Grosse Ile crossing was relegated to backup status and was only used when the Detroit-to-Windsor car ferry lanes were blocked with ice. It was abandoned completely in 1888. Although the through freight traffic was gone, the Michigan Central was still committed to serving the residents of Grosse Ile. In 1904, the railroad built a new brick station on the east side of the island and in 1920 was operating a pair of commuter trains between Grosse Ile and Detroit. (James Harlow collection.)

MICHIGAN CENTRAL DEPOT, HENDERSON. The Jackson, Lansing & Saginaw Railroad (a Michigan Central predecessor) completed its line through Henderson in October 1867. Despite its 1920 population of only 200, six of the eight Michigan Central Jackson-to-Bay City trains passing through the village were scheduled to stop here. The depot property included a small fenced-in lawn and garden running parallel to the gravel station platform. (James Harlow collection.)

MICHIGAN CENTRAL DEPOT, LACOTA. Located 32 miles northwest of Kalamazoo on the South Haven Branch, Lacota was originally known as Irvington. The Michigan Central, however, requested that the village's name be changed, since it already had a station on its Grand Rapids Branch named Irving. Lacota took its name from a fictional Native American maiden character contained in a novel being read by one of Irvington's residents. (James Harlow collection.)

113

MICHIGAN CENTRAL DEPOT, LAINGSBURG. The rail line between Owosso and Lansing via Laingsburg was one of the first components of the Michigan Central Railroad's Saginaw Branch, built by the Amboy, Lansing & Traverse Bay Railroad in 1858 and 1859. Between 1865 and 1867, the Jackson, Lansing & Saginaw Railroad added trackage south to Jackson and north to Bay City. The replacement depot at Laingsburg was a brick building with a bell-cast hip roof. (James Harlow collection.)

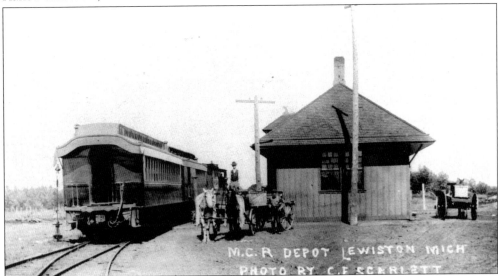

MICHIGAN CENTRAL DEPOT AND TRAIN, LEWISTON. When lumbering was king in the northern portion of Michigan's Lower Peninsula, the Michigan Central was operating more than 20 branch lines to various communities and logging camps. Lewiston, situated between East and West Twin Lake, was served by one of those branches. Other stops on the Twin Lake Branch between Grayling and Lewiston included Alexander, Kneeland, Bucks, Judges, Lovells, Bills, and Dana. (James Harlow collection.)

MICHIGAN CENTRAL DEPOT, LEWISTON. For a community with a 1920 population of 550, Lewiston's depot, not surprisingly, was a very small wood frame structure. However, simple enhancements like multipane window glass in the upper sashes, the small dormer over the operator's bay window, and decorative roof ridge trim spruced up an otherwise plain station plan. (James Harlow collection.)

MICHIGAN CENTRAL DEPOT, NASHVILLE. Nashville was located on the Grand Rapids Branch, 49.8 miles northwest of Jackson. The village was named after George Nash, the engineer in charge of Michigan Central construction. This replacement depot was completed in 1904 and was nearly identical in appearance to the Michigan Central station built on Grosse Ile that same year. (James Harlow collection.)

115

MICHIGAN CENTRAL DEPOT, NEWPORT. The Toledo, Canada Southern & Detroit Railway (a Michigan Central Railroad predecessor) was the second railroad to arrive in Newport in September 1873 and served the community from this wood frame depot. The Detroit, Monroe & Toledo Railroad (a New York Central Railroad predecessor) was the first to arrive here, when it completed its line between Detroit and Toledo, Ohio, in 1856. According to the joint New York Central and Michigan Central employee timetable No. 5, dated July 1, 1917, the two rail lines between the River Rouge drawbridge (south of Detroit) and Alexis (north of Toledo) were operated as double track. The New York Central was used as the southbound main, and the Michigan Central was used as the northbound main. At that time, the Newport station saw five northbound Michigan Central trains and four northbound New York Central trains each business day. (James Harlow collection.)

116

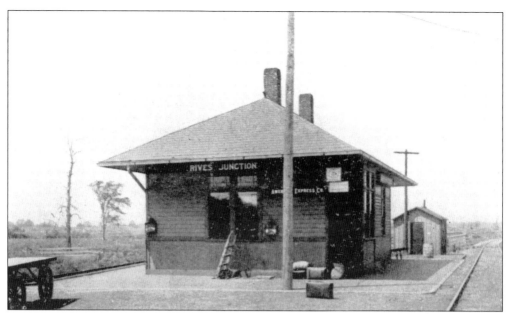

MICHIGAN CENTRAL DEPOT, RIVES JUNCTION. Rives Junction was an important location on the Michigan Central and was where its Grand Rapids and Saginaw Branches split apart, 10.4 miles north of Jackson. In addition to the 10 Grand Rapids and 8 Saginaw Branch trains in 1920, the village of 200 residents was also served by the Michigan Railway, which provided frequent electric interurban service between Jackson and Lansing. (James Harlow collection.)

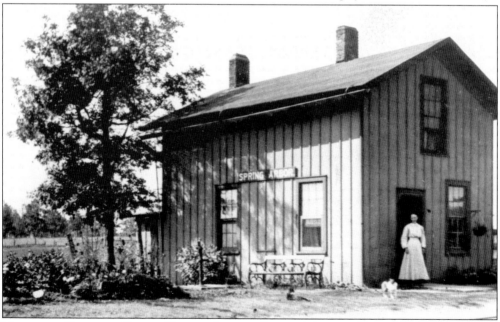

MICHIGAN CENTRAL DEPOT, SPRING ARBOR. Spring Arbor was located 10.3 miles west of Jackson on the railroad's Air Line Branch. With a shade tree, outdoor bench, and hanging flower basket, the depot was a pleasant place to await the arrival of a train. In June 1920, Spring Arbor was a flag stop for each of the four trains passing through the village. (James Harlow collection.)

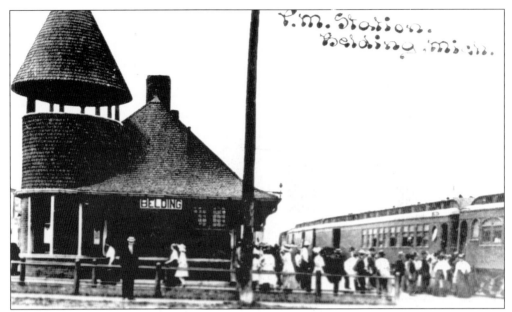

PERE MARQUETTE DEPOT, BELDING. With its open-air lookout area, the Belding depot presented a unique appearance. In November 1919, Belding was located on two service routes. The first was between Grand Rapids and Bay City. The second was between Grand Ledge and Big Rapids, and train operation between those two points was a bit complicated. During the course of the 122-mile trip, trains changed compass directions five times, including a backup move from Kidd to serve Belding. (James Harlow collection.)

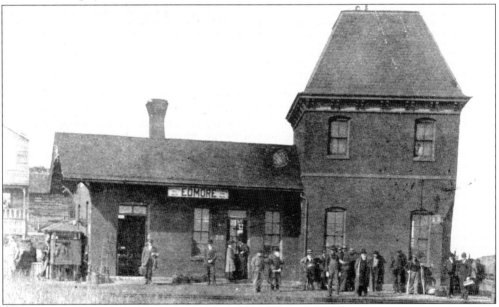

PERE MARQUETTE DEPOT, EDMORE. The depot at Edmore was a Michigan classic. Its L-shaped design featured two, one-story gable-roof sections joined to a square, mansard-roofed, two-story tower. The Pere Marquette Railway radiated out of Edmore in four different directions. The primary route was the one between Bay City and Grand Rapids via Stanton and Elmdale. There were also branch lines to Big Rapids and Howard City. (James Harlow collection.)

118

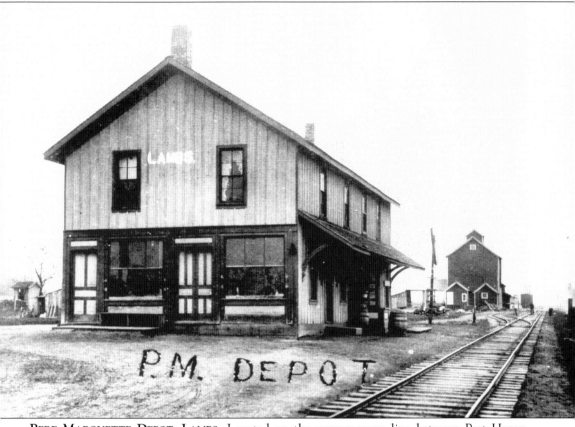

PERE MARQUETTE DEPOT, LAMBS. Located on the narrow-gauge line between Port Huron and Almont, built by the Port Huron & Northwestern Railway in 1882, Lambs was located 15.8 miles southwest of Port Huron. The company had considered extending the line to Detroit, but nothing ever materialized. There was also talk at one point about building west to Flint or even Chicago, but the line remained little more than agricultural branch. The Flint & Pere Marquette Railroad purchased the entire Port Huron & Northwestern in 1889 and systematically converted the railroad to standard gauge, except for the Almont Branch. Ultimately, it was the Pere Marquette Railroad (successor to the Flint & Pere Marquette) that standard gauged the Almont line in May 1903. According to its timetable dated June 6, 1920, daily-except-Sunday passenger service was provided by train No. 311 and No. 312. Train No. 312 left Almont at 11:00 a.m., with a flag stop in Lambs at 12:15 p.m., and had a 1:15 p.m. arrival in Port Huron. Westbound train No. 311 departed Port Huron at 3:15 p.m., Lambs at 4:14 p.m., and was back in Almont at 5:35 p.m. (James Harlow collection.)

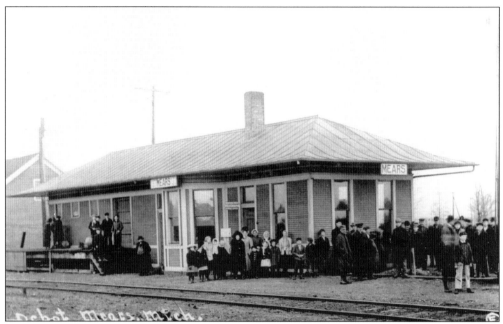

PERE MARQUETTE DEPOT, MEARS. The Chicago & Michigan Lake Shore Railroad (a Pere Marquette Railway predecessor) completed the final 26.8 miles of its line from Holland to Pentwater via Mears in January 1872. Mears was also the junction for the short branch line to Hart, which was completed eight and half years later. Contrasting wood trim was the only technique employed to dress up the Mears depot. (James Harlow collection.)

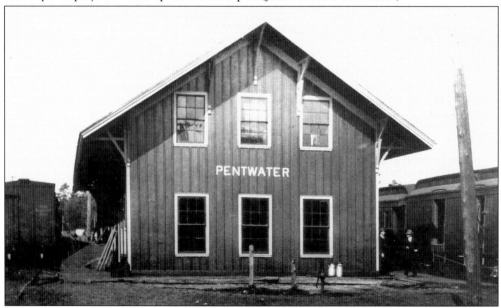

PERE MARQUETTE DEPOT, PENTWATER. Pentwater was the last station on the 76-mile branch line running north out of Holland. According to its timetable dated November 30, 1919, the Pere Marquette was operating two pairs of trains between Holland and Pentwater. The schedule provided travelers a choice of morning or evening arrivals (and departures) at Pentwater each business day. (James Harlow collection.)

120

Six

TWO SPECTACULAR SAVES

Without question, many Michigan railroad stations enjoyed their heyday in the second decade of the 20th century, but for some of them, the story does not end there. A surprising number of the state's railroad stations have soldiered on, despite the widespread elimination of passenger train service in the post–World War II era. Today, even with limited Amtrak passenger service and the relatively small number of active train stations required, Michigan has been blessed with a large number of depot restoration projects in recent years. Immaculately restored stations, large and small, have been the end result of these projects, and each would make an interesting story in itself. The two major depot restoration projects depicted in this chapter evidence the challenges and triumphs involved in such endeavors. In each case, the obstacles faced by project managers were many, but gifted minds and skillful hands were able to save these buildings from uncertain futures. The completed depot restoration projects at Durand and Niles have both produced renewed structures that are truly spectacular.

Unable to justify the continued expense of maintaining the Durand station, the Grand Trunk Western Railroad announced in 1974 that it was planning to abandon the historic structure. Recognizing that an important part of city history could soon be lost, the community embarked on a campaign to save the depot. After years of difficult negotiations, the city and the railroad finally reached an agreement in 1979, whereby the city purchased the station for $1 and leased the land for an identical amount. Today, the depot is beautifully restored inside and out, and now serves Amtrak's *Blue Water* trains as well as being home to the State Railroad History Museum. With its beautiful chateau Romanesque architecture, the station is one of the most photographed railroad depots in Michigan.

The 1892 Michigan Central Railroad station at Niles was a grand structure that could have easily passed for a cathedral. In fact, its massive trackside facade was so impressive that a similar design was used in 1896 on St. Andrews Presbyterian Church in Windsor, Ontario. Unfortunately, the Niles depot had begun to show signs of its age by 1970, after several years of minimal upkeep by the financially ailing Penn Central Transportation Company. Thankfully Amtrak and the Michigan Department of Transportation stepped in with a major renovation effort in 1988. Today, the depot is arguably one of the most beautiful in Michigan and continues to serve the Niles community as a station stop for Amtrak's *Wolverine* and *Blue Water* trains.

TWO SPECTACULAR SAVES

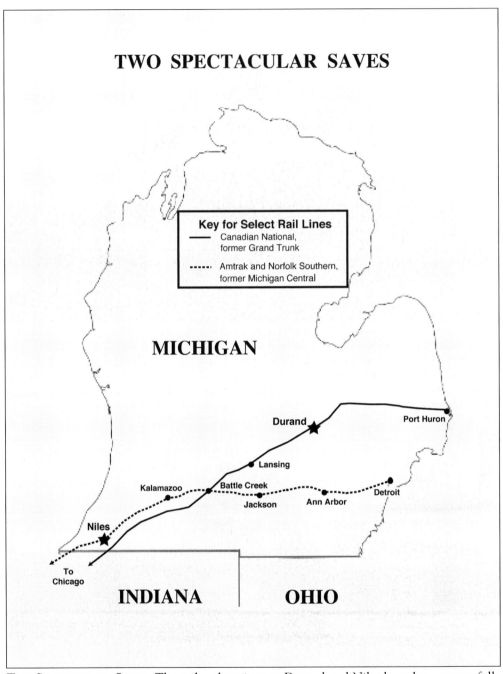

Key for Select Rail Lines
— Canadian National, former Grand Trunk
····· Amtrak and Norfolk Southern, former Michigan Central

MICHIGAN

Durand

Port Huron

Lansing

Kalamazoo Battle Creek

Jackson Ann Arbor Detroit

Niles

To Chicago

INDIANA OHIO

TWO SPECTACULAR SAVES. The railroad stations at Durand and Niles have been masterfully restored, giving both structures a new lease on life.

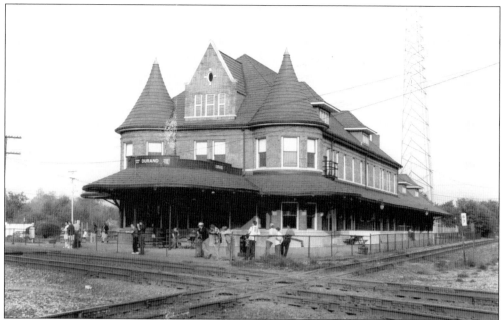

GRAND TRUNK DEPOT, DURAND, MAY 17, 2003. With its nine roof dormers restored and red tile roof installed, Durand Union Station was ready for its two upcoming 100th anniversary celebrations—the first on October 1, 2003, and a second on September 25, 2005. The 2003 centennial celebration commemorated the opening of the original station, while the various centennial events of 2005 marked the reopening of the fire-damaged Durand station. (Photograph by David J. Mrozek.)

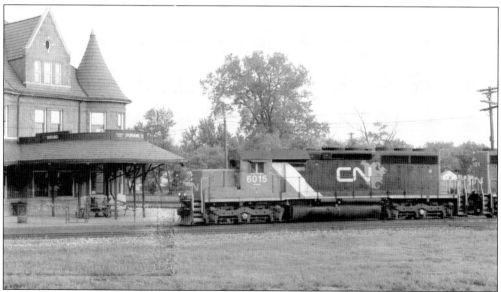

CANADIAN NATIONAL TRAIN 394 AT DURAND, JUNE 1, 2003. Train No. 394, lead by SD40-2Q locomotive No. 6015, wearing the short-lived CN North America paint scheme, accelerates as it passes the restored Durand station and heads toward Flint. Picnic tables under the depot's unique, curved front awning provide a comfortable vantage point for enthusiasts to watch trains passing through town. (Photograph by David J. Mrozek.)

123

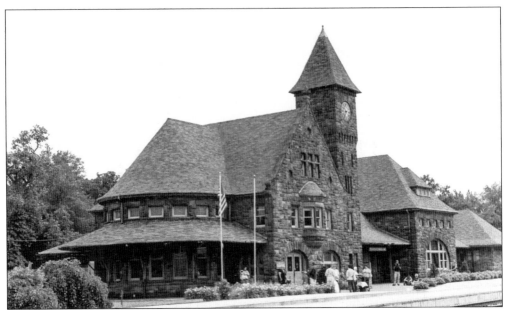

MICHIGAN CENTRAL DEPOT, NILES, JUNE 22, 2006. Without question, the Niles depot presents a stunning appearance from any vantage point. This trackside view looking southeast shows the station's semicircular waiting room, cathedral-like front gable, clock tower, and platform landscaping. Inside, the depot's restored waiting room presents an equally impressive appearance, with its oak benches, beautiful chandeliers, fireplace, and restored wood work. (Photograph by David J. Mrozek.)

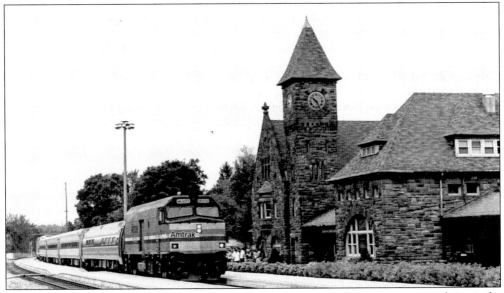

AMTRAK TRAIN 350 ARRIVING AT NILES, JUNE 22, 2006. While not apparent on the outside, the depot's interior space was reconfigured substantially during its restoration. Though the waiting room's location did not change, the ticket counter was moved to the former smoking room. The balance of the floor space was remodeled to accommodate the needs of Amtrak's engineering staff. With passengers waiting, train No. 350 slows to a stop in front of the station. (Photograph by David J. Mrozek.)

124

BIBLIOGRAPHY

Berry, Dale J., Webmaster. RRHX: Railroad History of Michigan. "Station Menu by County." www.michiganrailroads.com/RRHX/Stations/StationCountyMenu.htm.

Cousins, Garnet R., and Paul Maximuke. "Detroit's Last Depot." *Trains Magazine*, August and September 1978.

Dodge, Roy L. *Michigan Ghost Towns of the Lower Peninsula and Upper Peninsula*. Las Vegas, NV: Glendon Publishing, 1990.

Dunbar, Willis F. *All Aboard - A History of Railroads in Michigan*. Grand Rapids, MI: William B. Eerdmans Publishing, 1969.

Grant, H. Roger. *Railroad Postcards in the Age of Steam*. Iowa City, IA: University of Iowa Press, 1994.

Hilton, George W. *American Narrow Gauge Railroads*. Stanford, CA: Stanford University Press, 1990.

Meints, Graydon M. *Along the Tracks - A Directory of Named Places on Michigan Railroads*. Mount Pleasant, MI: Clarke Historical Library, Central Michigan University, 1987.

———. *Michigan Railroad Lines*. Vols. 1 and 2. East Lansing, MI: Michigan State University Press, 2005.

———. *Michigan Railroads & Railroad Companies*. East Lansing, MI: Michigan State University Press, 1992.

Middleton, William D., George M. Smerk, and Roberta L. Diehl. *Encyclopedia of North American Railroads*. Bloomington, IN: Indiana University Press, 2007.

Olds, Fred C. "Petoskey: Northern Michigan Commuter Capital." *Inside Track*, May–June 1979.

Petcher, Charles R. "Fort Street Union Depot (1893-1974)." *Michigan Railfan*, Michigan Railroad Club, March 1974.

Potter, Janet Greenstein. *Great American Railroad Stations*. New York, NY: J. Wiley & Sons, Inc., 1996.

Romig, Walter. *Michigan Place Names*. Detroit, MI: Wayne State University Press, 1986.

Stroup, Donald. *The Manistee & Northeastern Railroad - The Life and Death of a Railroad*. Lansing, MI: Historical Society of Michigan, 1964.

Thornton, W. Neil. *High Iron Along the Huron Shore*. Tawas City, MI: Printer's Devil Press, 1982.

Trostel, Scott D. *The Detroit, Toledo & Ironton Railroad, Henry Ford's Railroad*. Fletcher, OH: Cam-Tech Publishing, 1988.

Uhelski, John M., and Robert M. Uhelski. *An Inventory of Railroad Depots in the State of Michigan*. Railroad Station Historical Society, 1979.

INDEX TO STATIONS

126

ACROSS AMERICA, PEOPLE ARE DISCOVERING SOMETHING WONDERFUL. *THEIR HERITAGE.*

Arcadia Publishing is the leading local history publisher in the United States. With more than 3,000 titles in print and hundreds of new titles released every year, Arcadia has extensive specialized experience chronicling the history of communities and celebrating America's hidden stories, bringing to life the people, places, and events from the past. To discover the history of other communities across the nation, please visit:

www.arcadiapublishing.com

Customized search tools allow you to find regional history books about the town where you grew up, the cities where your friends and family live, the town where your parents met, or even that retirement spot you've been dreaming about.